DIOR by Yuriko Takagi

New York · Paris · London · Milan

7
Timeless Conversation
Kazuko Koike

9
Toiles, Outlines of the Dress
Olivier Saillard

15
Photographs

150
Captions

Timeless Conversation

Yuriko Takagi continues the conversation.
 She first engages in dialogue with the very space she inhabits, seemingly as wide and open-ended as her expansive studio, yet equally evoking the intimacy of a Japanese tearoom. The photographer seems to breathe life into this mutable space with an atmosphere of her own.
 In the depths of this space, a presence is felt, toward which Yuriko cautiously makes her way.
 The air stirs as an exquisite array of projected images come into focus. One can almost feel the artist's inner satisfaction.
 She places some *toiles* there, setting the stage for further dialogue.
 30 Avenue Montaigne. Yuriko's camera eye pays the legendary address a visit. Glimpses of the building that has long stood on the site, then as now, are absorbed by her camera eye as memories that materialize out of the blue.
 These images emerge at irregular intervals along the passage of time, revealing the surrealistic world envisioned in Yuriko's mind's eye.
 Toiles. The camera quietly pans across the *toile* prototypes, showcasing the very form of the dress as the star of the show, proudly accompanied by a supporting cast of hats, shoes, and jewelry.
 A cascading dance of imagery unfolds with layer upon layer of flower petals, overjoyed at the suggestion that they themselves are the dress.
 Where has time gone?
 To the farthest reaches of Yuriko's gaze.
 The time for a dialogue with Christian Dior.

Kazuko Koike

Toiles, Outlines of the Dress

Fashion is a calligrapher—albeit unknowingly. Ever since the birth of haute couture in the late nineteenth century, we have celebrated its subtle choices of materials and textiles, and the art of the cut. We have rejoiced over the lines of stylized sketches and drawings, but little has been said of its use of words and letters. Yet the pen is involved at every stage of a collection's creation; and, from crossed-out jottings on the corner of a tabletop to commentaries composed in response to runway shows, the written word has proved a mainstay for the couturier's ideas.

Be they explanatory working notes that set out the future collection's intentions, or instructions handwritten directly onto the ecru-toned cotton *toiles* that prefigure the garments themselves, concise, prescriptive words steer the work of the ateliers.

Of all his peers, Christian Dior was the most attuned to the spoken and written word. The baton that he used to point at the *toiles* or at pieces being fitted was a descriptive, corrective tool, and the *toiles* the blank pages that would soon be annotated with his intentions, which the workshops would have to obey to the letter!

The press releases and press kits that accompanied each of his collections between 1947 and 1957 were summaries through which he justified his choices and shared them with as many people as possible. Dior theorized his ideas, sometimes through technical descriptions and at other times poetically, and grouped his creations together under distinct headings, according to whether they followed the form of the letter *A*, *H*, or *Y*—each of which defined the silhouette of one of his lines. Instead of an anonymous code or a factual number, Dior gave his creations names; *Chérie*, *Bonbon*, and *Cocotte* formed intriguing sisterhoods. Thus named, the dresses, coats, and suits formed a repertoire that was reinvented every season.

This body of work grew and grew as the years went by. It would always begin with a drawing which, in Dior's case, served as vocabulary. Whether that sketch was quick or sophisticated, purely allusive or highly detailed, the ateliers would have to translate and decipher what sometimes amounted to a sartorial premonition. Dior himself, in his 1956 book *Christian Dior et moi* (published in English translation as *Dior by Dior* the following year), explains:

"Like the sketches which inspired them, these *toiles* have very little detail; their importance is entirely in their silhouette, cut and line. These are the fundamental *toiles* on which the whole collection is based. Details like lapels, bows, pockets, cuffs and belts, are added later unless they happen to be indispensable to the construction of the model."[1]

The white or ecru-toned *toile*, generally made of cotton, thus served as a study process and proof before the great leap into the final chosen fabric. It was where a skirt's generous volumes were confidently cut, and where the strictly dictated 1950s hemlines were evaluated, and where a new style of armhole or collar was perfected. On this fabric, untouched by color and materially neutral, the drawing is embodied for the first time, in rough proportions. There is not yet any wool, satin, motif, or embroidery. The architecture of the garment is displayed even more clearly in the *toile*, which maintains the odd paradox of a blank page unclaimed by any particular discourse and yet already revealing its story. *Toiles* are like loose leaves that the head seamsters of an atelier can unhesitatingly cut into, without fearing they will sacrifice precious fabric. They have the candor of the newborn while already bearing the suggestion of memory. Provisional maquettes, screens, or negatives onto which the next collection's pieces are projected, they hold the ambiguous status of being ghosts and specters yet also proud trailblazers, launching new ideas.

In all the subjects that Yuriko Takagi chooses to photograph, she seems to reveal a sort of nudity.

In the portraits that she made while traveling in Asia, Africa, South America, and the Middle East, she discreetly draws close to the subjects' faces to create a blur between their daily reality and their intimacy. The landscapes that she passes through and singles out are likewise caressed by a humanity of which Yuriko Takagi appears to be the appointed conservator. Possessing a sensibility for fashion and graphic design, which she studied and practiced before concentrating on photography, it is with great thoughtfulness and care that she pays homage to the series of *toiles* and finished pieces created by Christian Dior and the artistic directors of his couture house who succeeded him. The floral themes that Dior himself so loved blossom naturally. Petals and petticoats coordinate in chorus. The ornamental details of a suggested architecture seem to be pinpointed rather than imposing themselves. The models join the dance. Their poses are ethereal. Whether in timeless black-and-white or the colors of memory, Yuriko Takagi's photographs reject all the harshness of reality, and the clothes, all aquiver, come to life with the ease of a breath.

In this exercise—part archaeology and part poetry—the virgin *toiles* that prefigured the finished garments become projection screens, fleeting traces of each decade's celebrated shapes and creations. As librettists for a silent, subtle opera, they lyrically conduct a fashion score that still lives on, renewed every season. As life is thus breathed back into these parched

fabrics, the skeletons of dresses, coats, and jackets are revealed in their ivory whiteness. Orchestrated around the bodies they accompany, becoming their signature as beating wings are a bird's, these canvas drafts are also renderings of Christian Dior's primary aspiration.

"I wanted to be an architect; being a fashion designer, I am obliged to follow laws, principles of architecture. [...] It is perfectly valid to speak of the architecture of a dress. A dress is constructed, and it is constructed according to the direction of the fabrics [...] that is the secret of couture, and it's a secret that depends on the first law of architecture: that of obeying gravity."[2]

An architect couturier who had no objection to words celebrating his style, Christian Dior was behind the most sensational of fashion trends. A colorist who did not shy away from the rules or the entertainment value of pattern, he was also the inventor of methodically developed garments that only the exclusive industry of haute couture could take forward. As he would say: "Without the constraints of rules, there is no creative freedom." Envisioning a garment, drawing out its design in two dimensions on paper and then onto the *toile*, copying it onto the chosen fabric, cutting it, attaching the pieces together, separating or uniting the opposite ends, finely stitching, and successfully achieving a beautiful three-dimensional silhouette: each of these rigorous, skillful steps has something of science and mathematics about it. Within this constricted, technical field, not everyone is capable of injecting a sense of creativity into a sleeve. Christian Dior was a master of it. He derived great satisfaction from it, and he wrote his life story through dresses. The *toile* mock-ups that came out of this, and which anticipated those gowns, are the ultimate initials heralding what was to become his signature style.

Olivier Saillard

[1] Christian Dior, *Dior by Dior: The Autobiography of Christian Dior* (London: V&A Publishing, 2024), 91.
[2] Christian Dior, translated from "Conférence du 3 août 1955," *Conférences écrites par Christian Dior pour la Sorbonne, 1955-1957* (Paris: Éditions de l'Institut français de la mode/Éditions du Regard), 43.

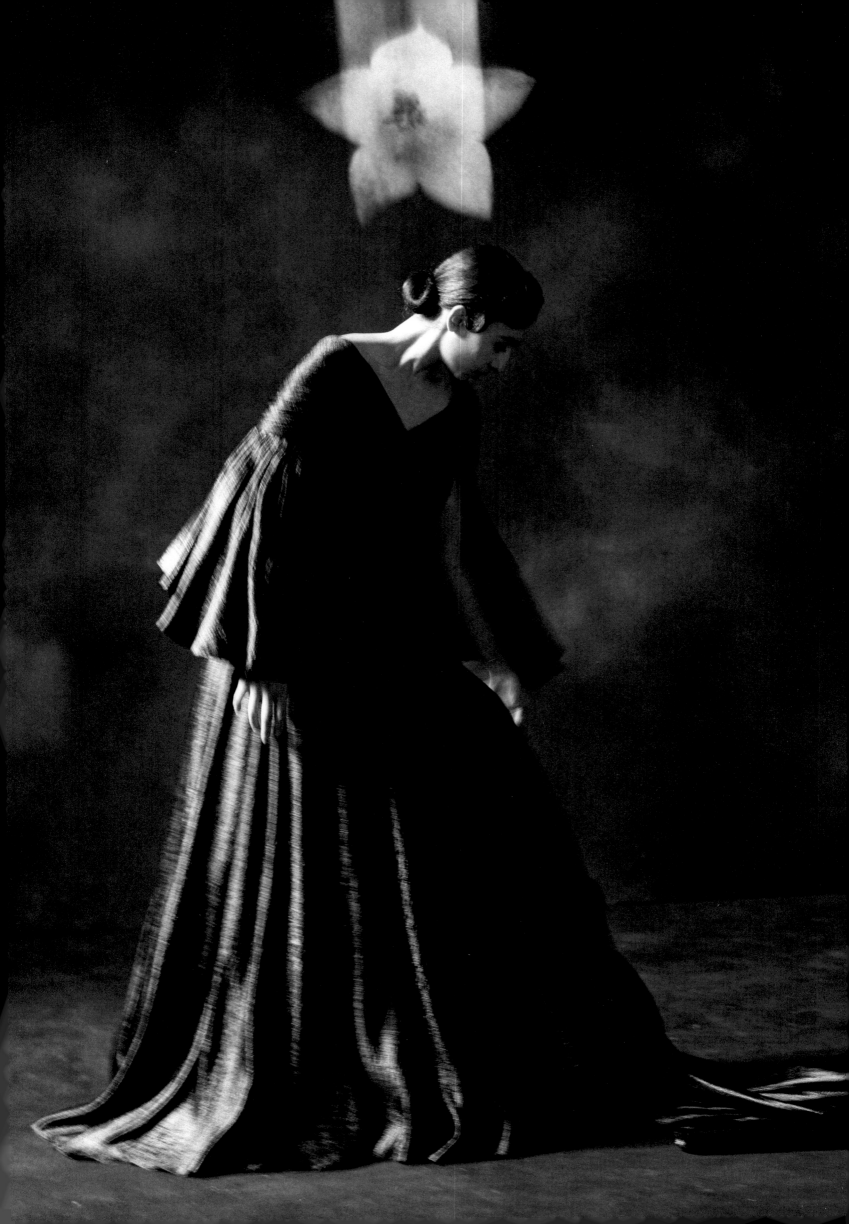

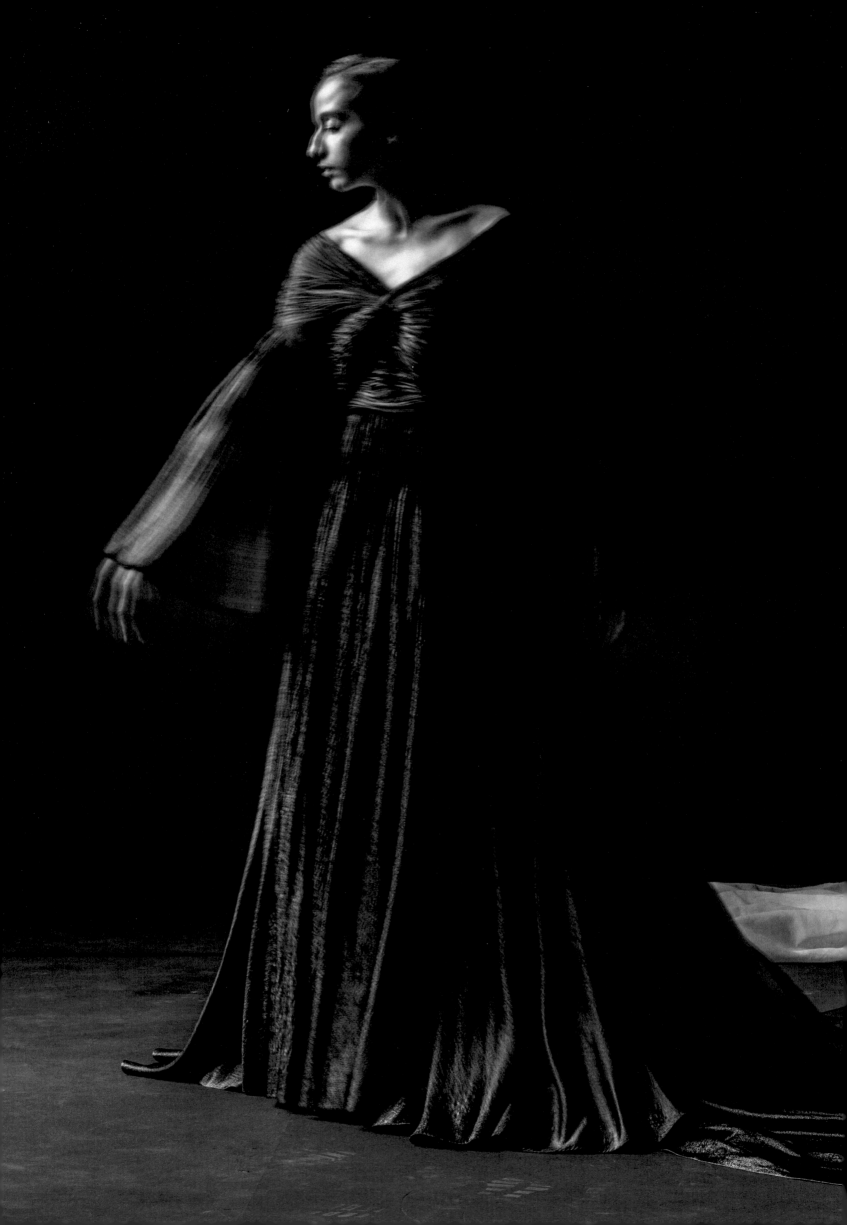

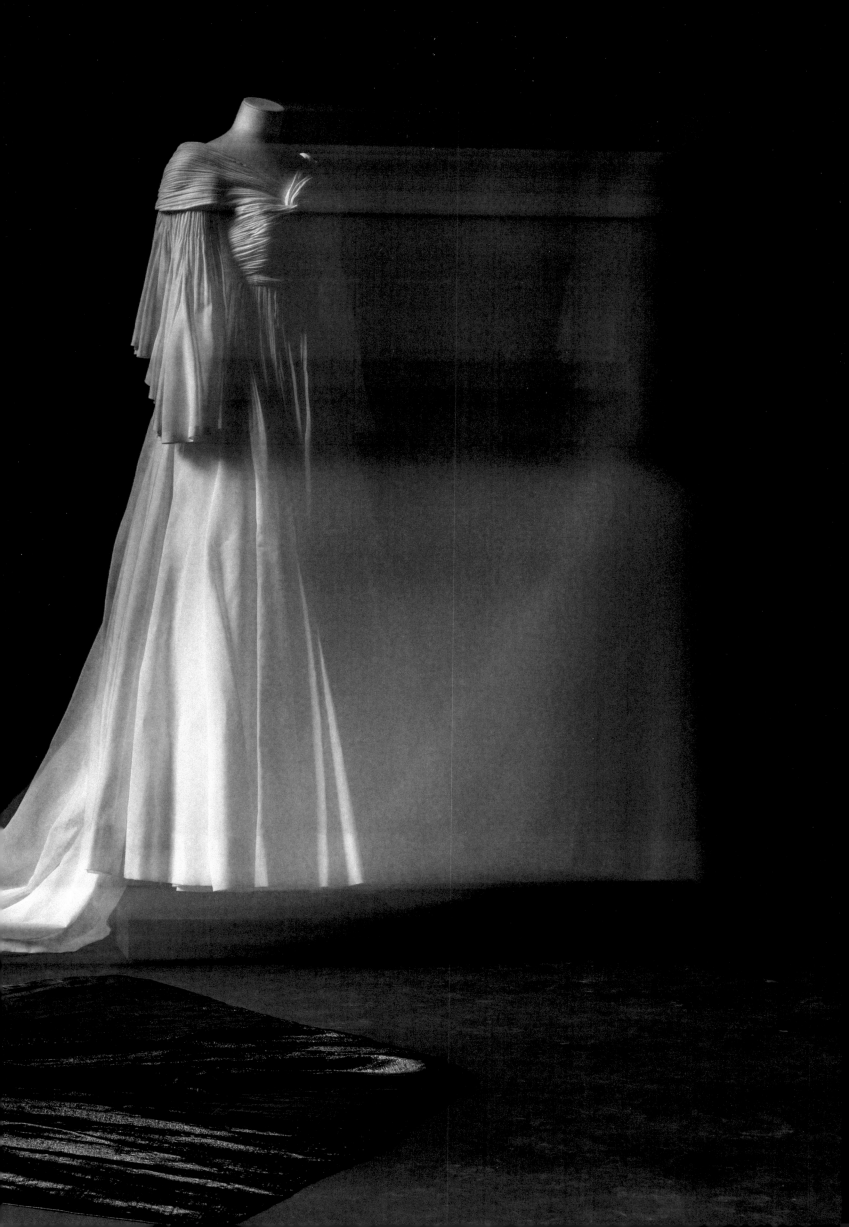

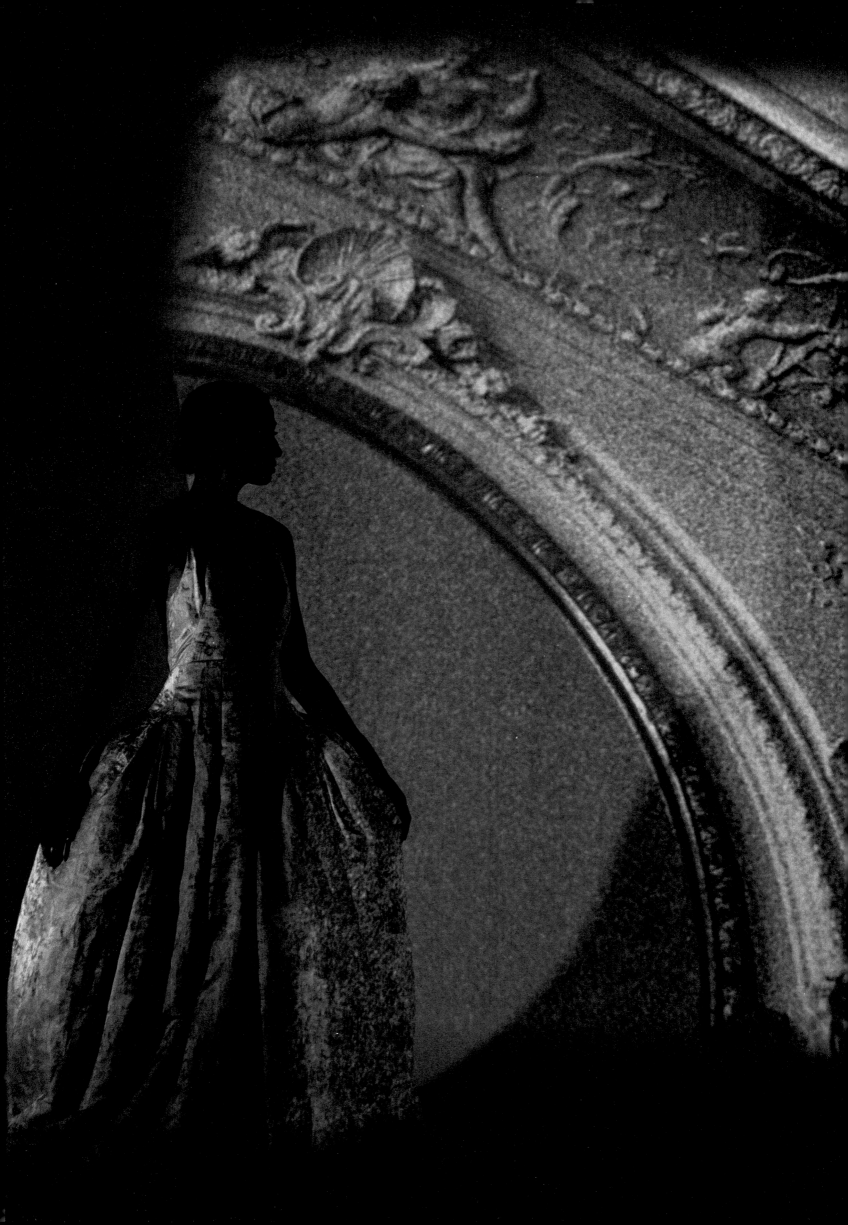

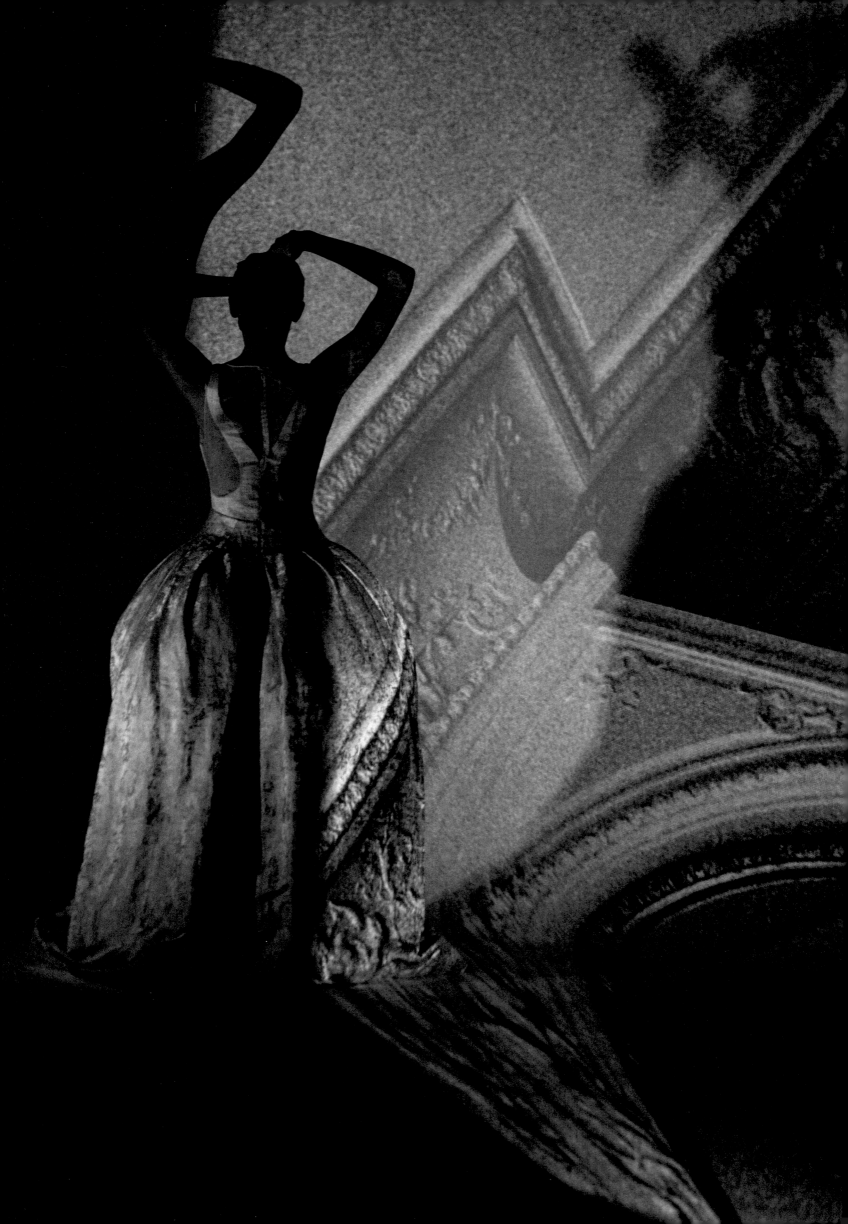

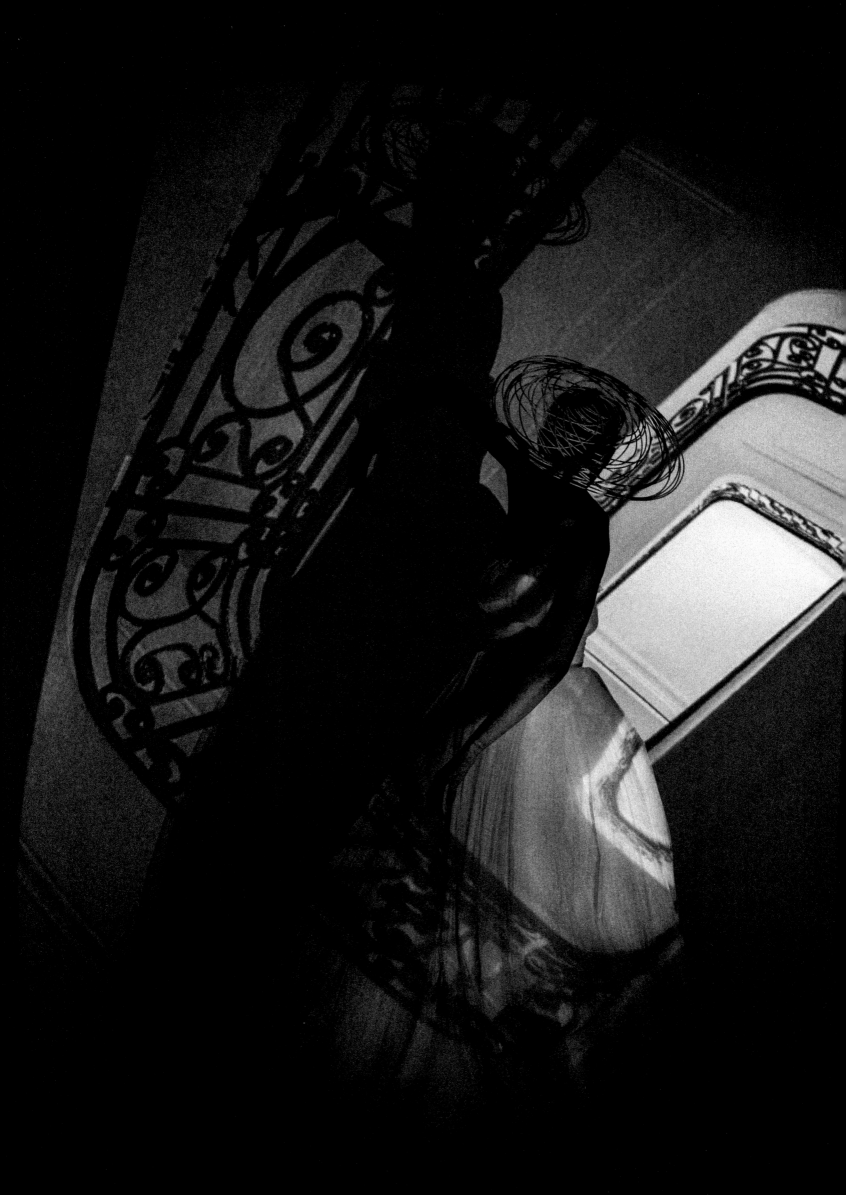

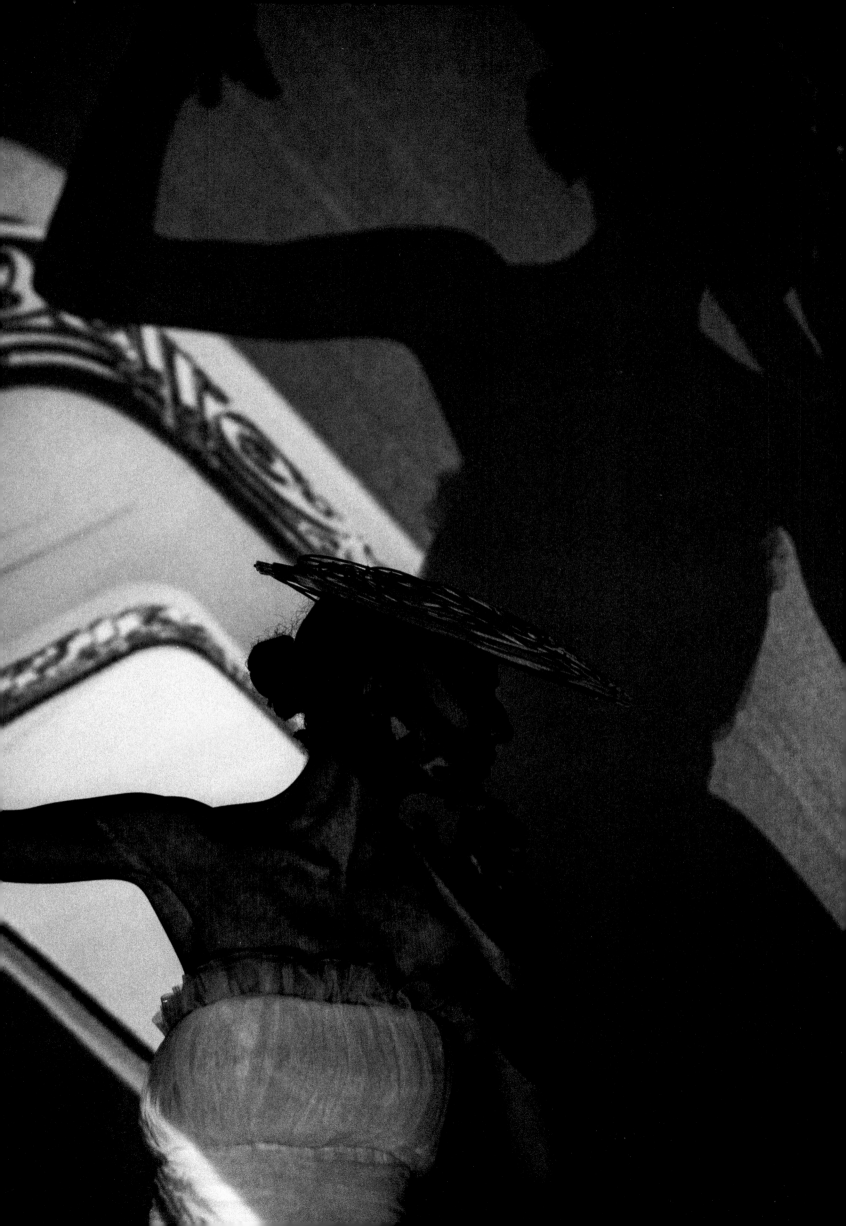

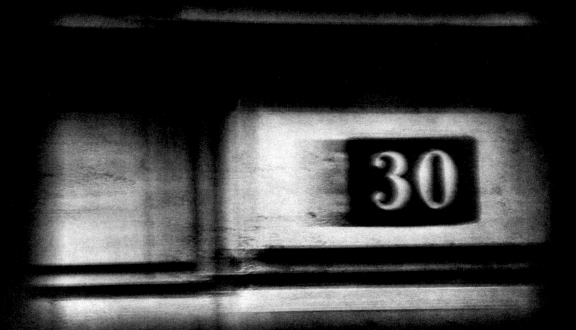

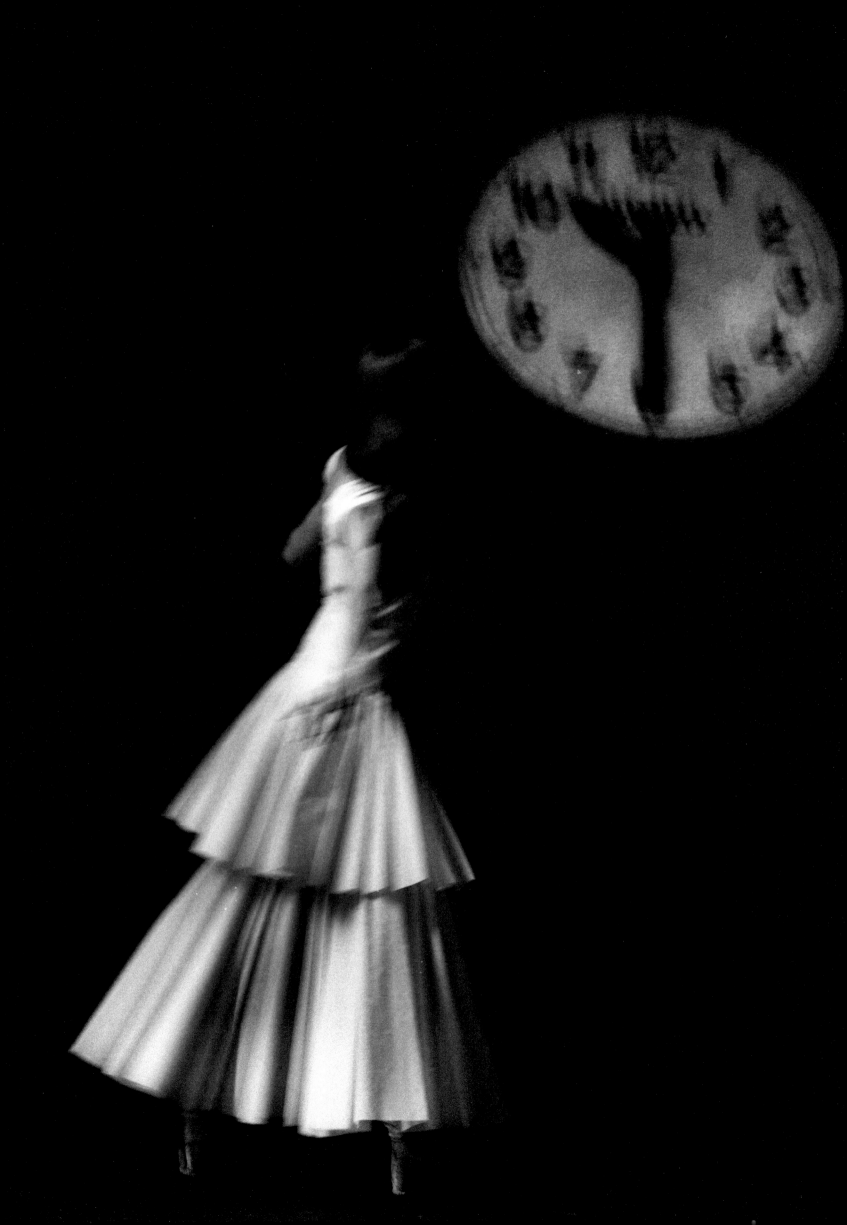

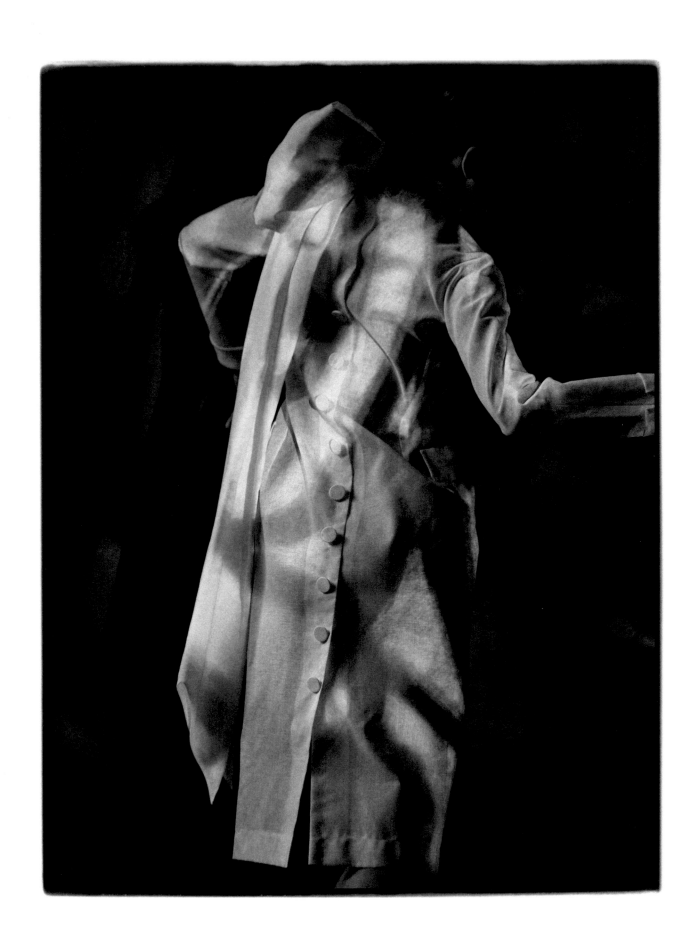

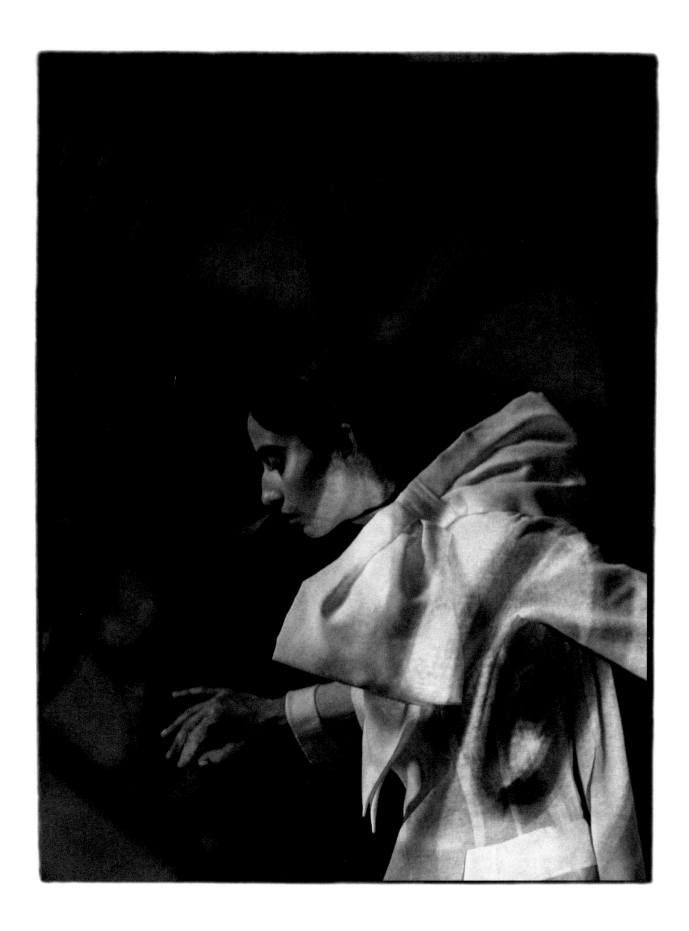

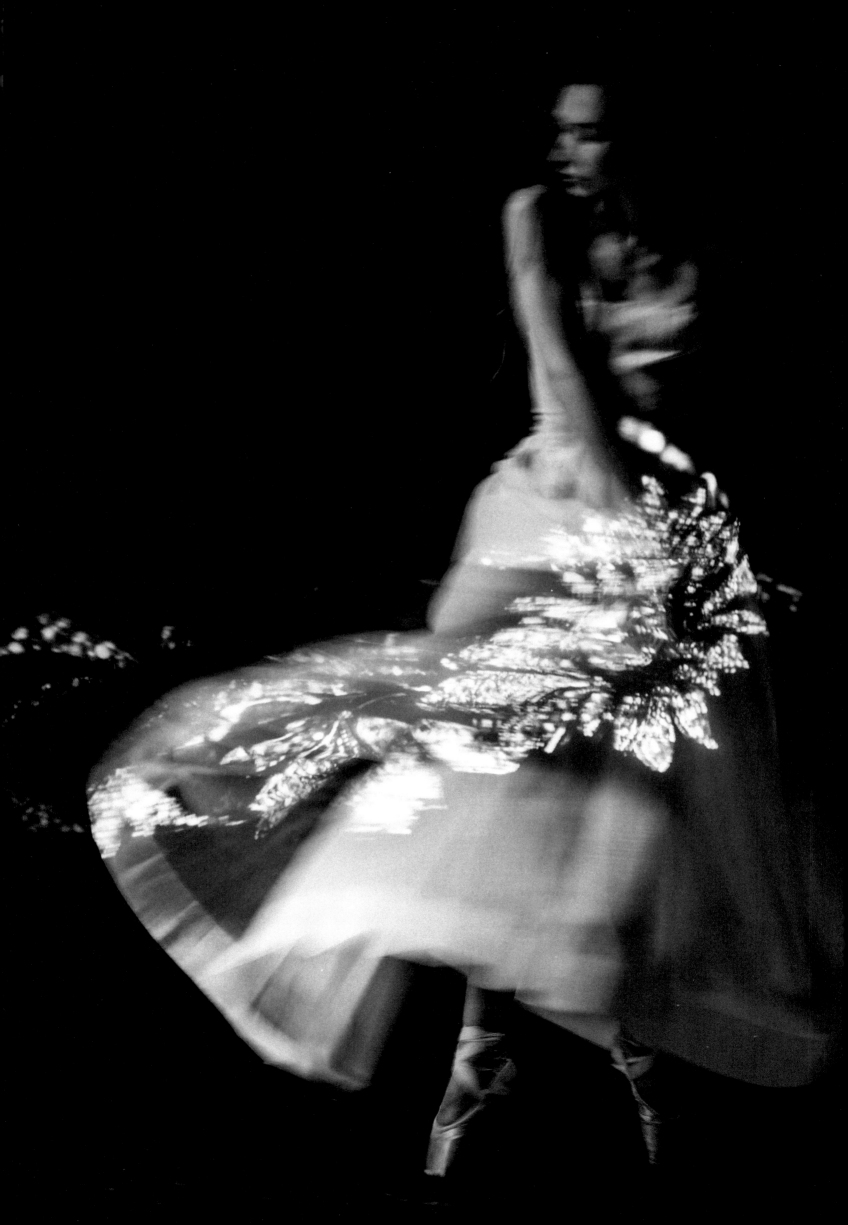

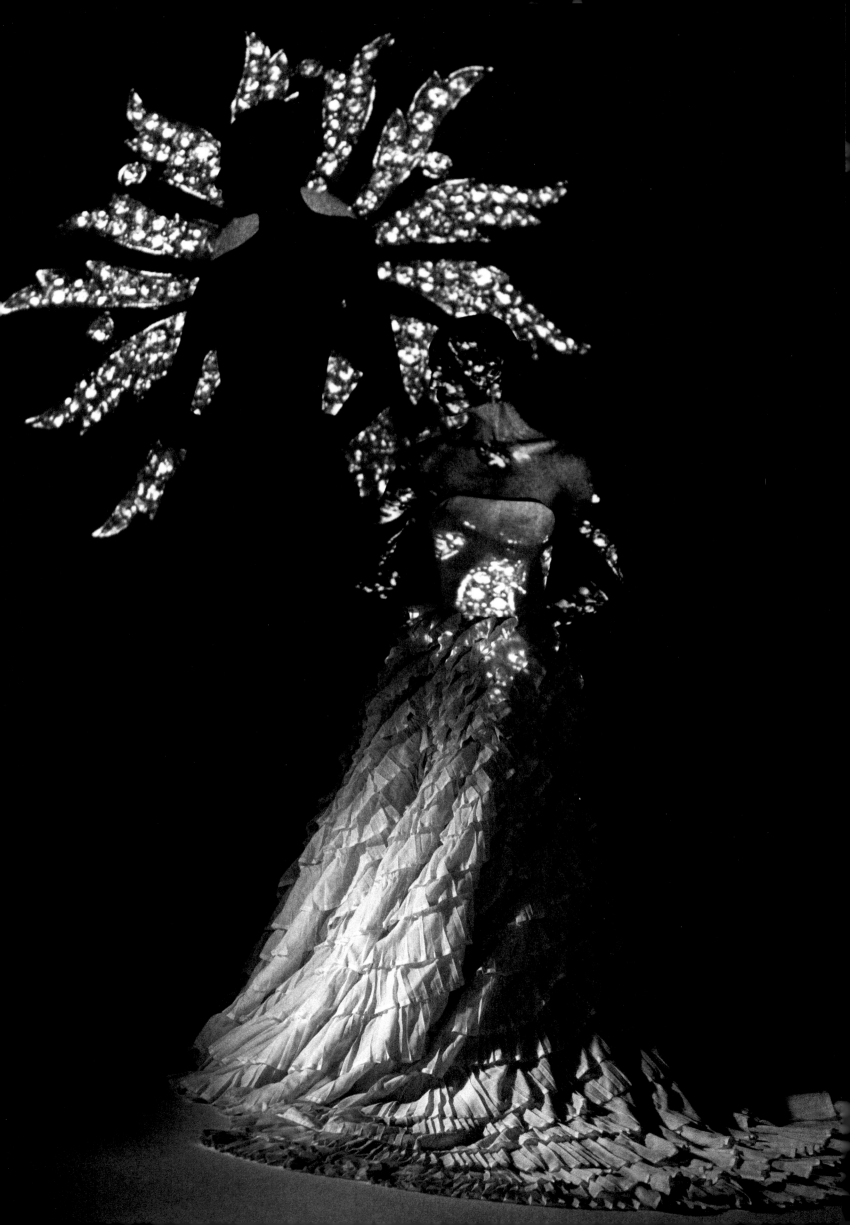

BEING LOADED
WITH THE UNKNOWN,
MYSTERIOUS,
AND SURPRISING,
FASHION HAS
RETURNED TO BEING
ONE OF THE LAST
REPOSITORIES
OF THE MARVELOUS.

C.D.

BEING LOADED
WITH THE UNKNOWN,
MYSTERIOUS,
AND SURPRISING,
FASHION HAS
RETURNED TO BEING
ONE OF THE LAST
REPOSITORIES
OF THE MARVELOUS.

C.D.

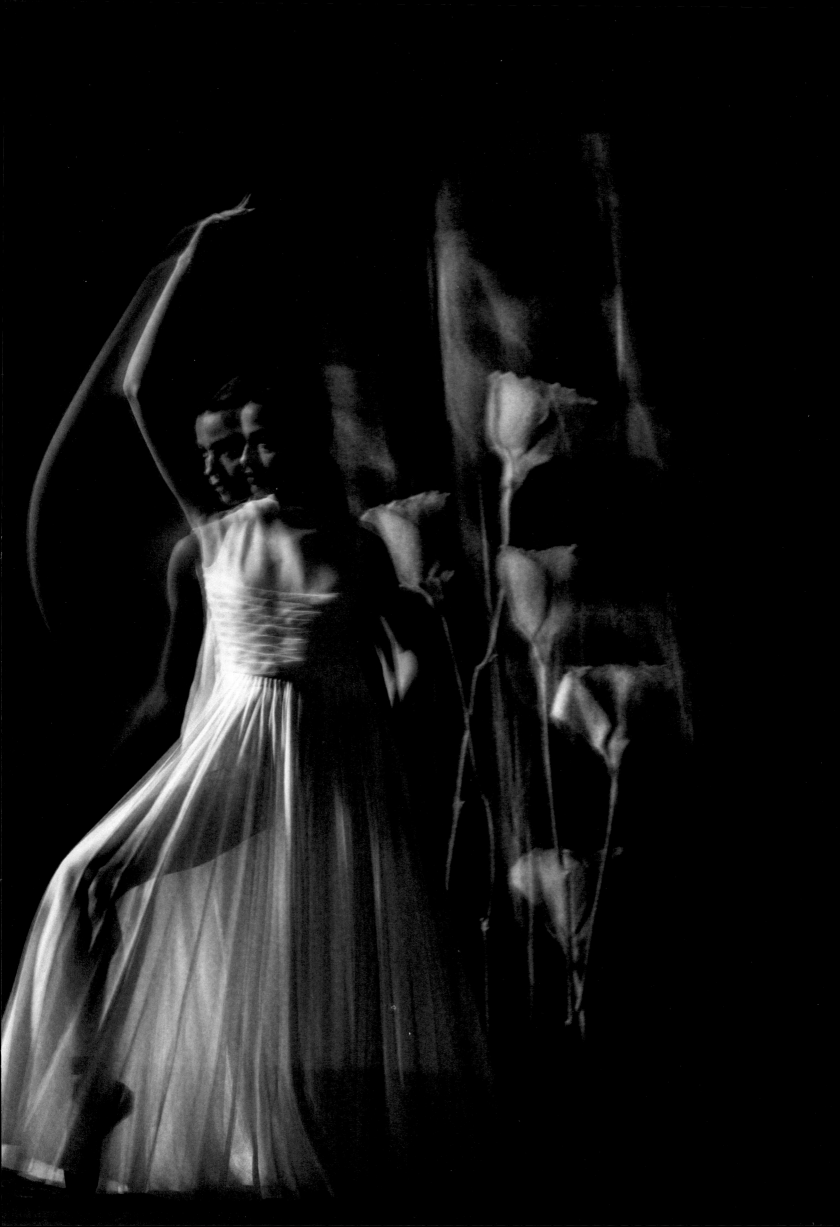

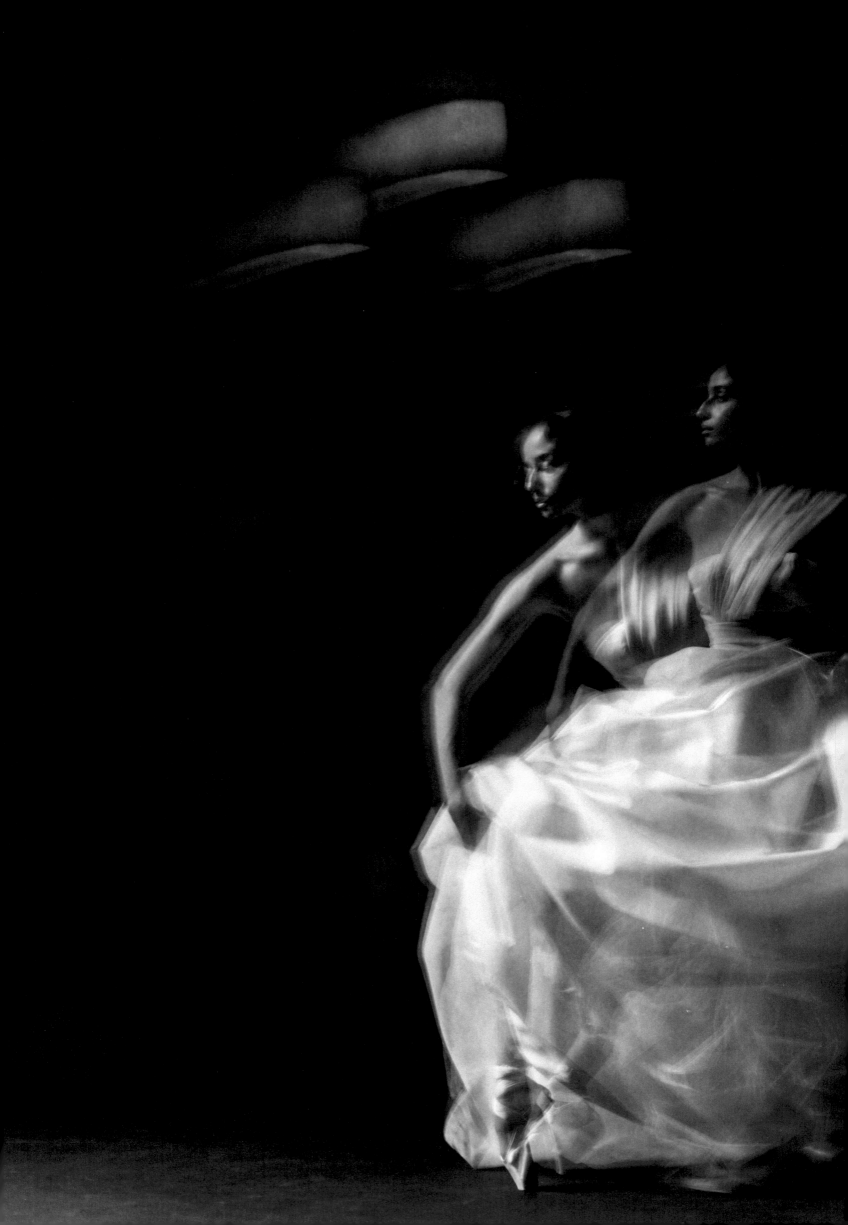

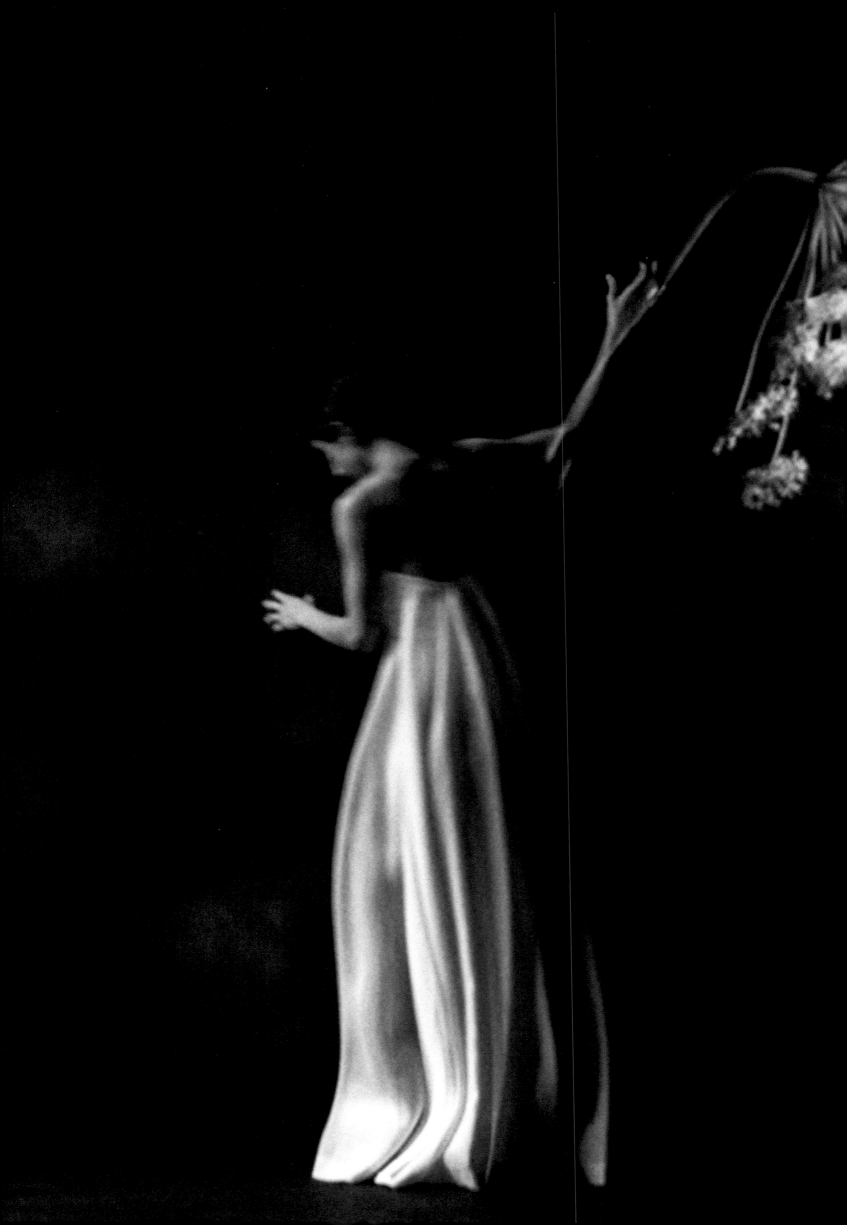

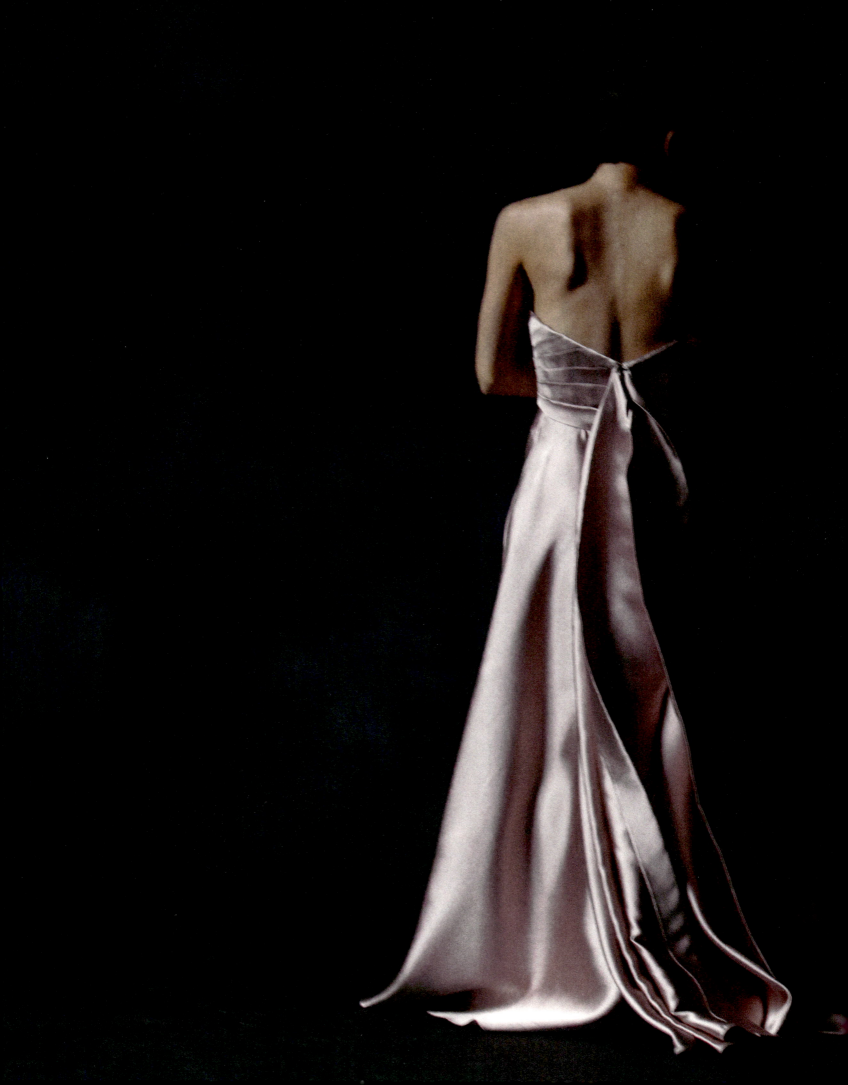

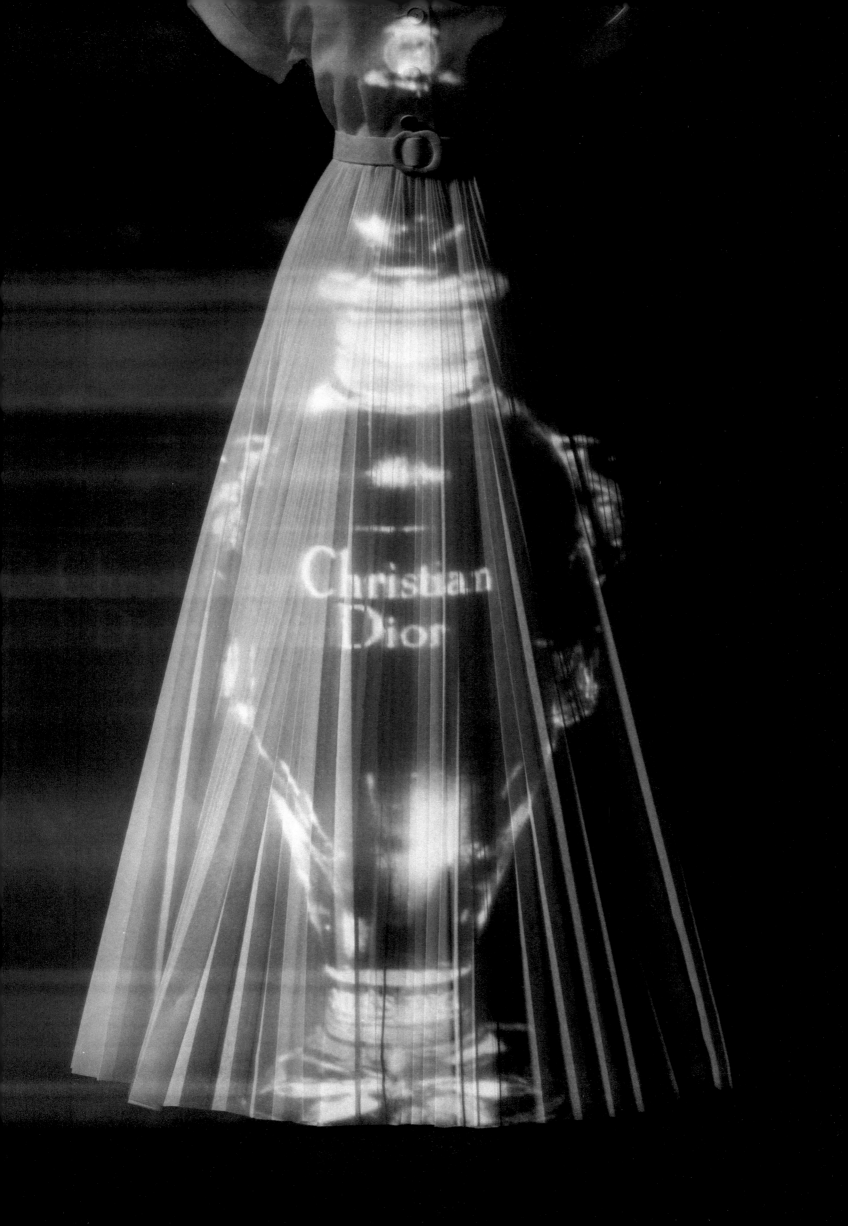

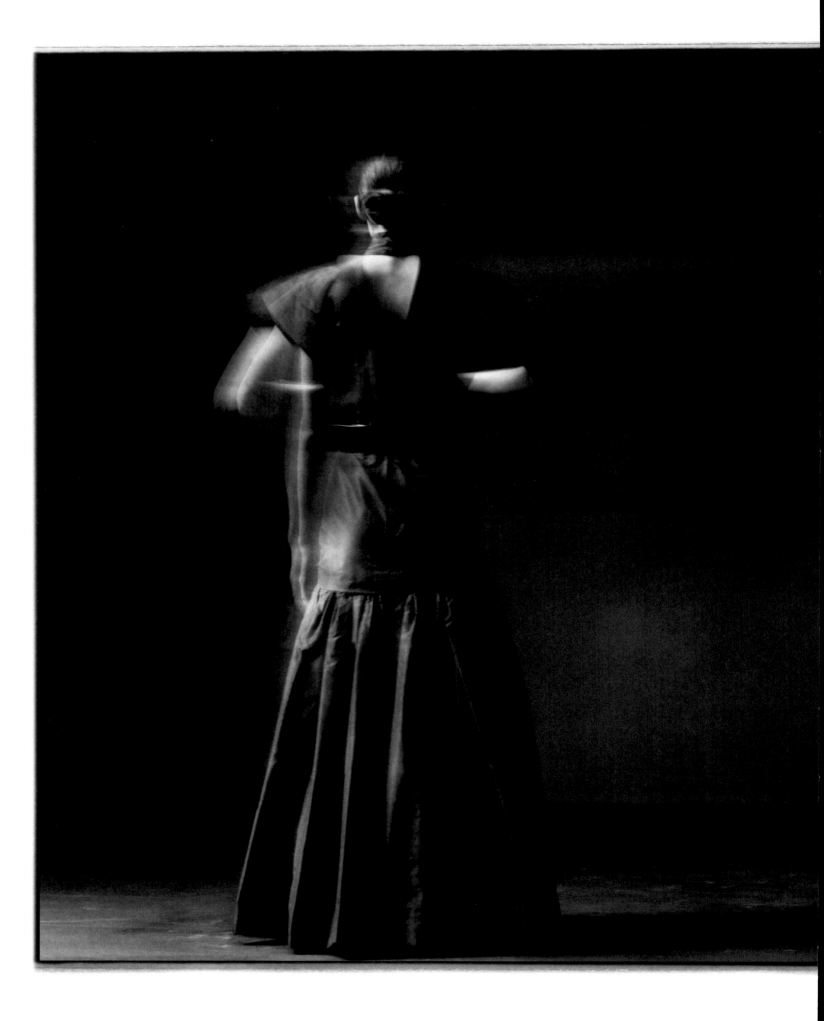

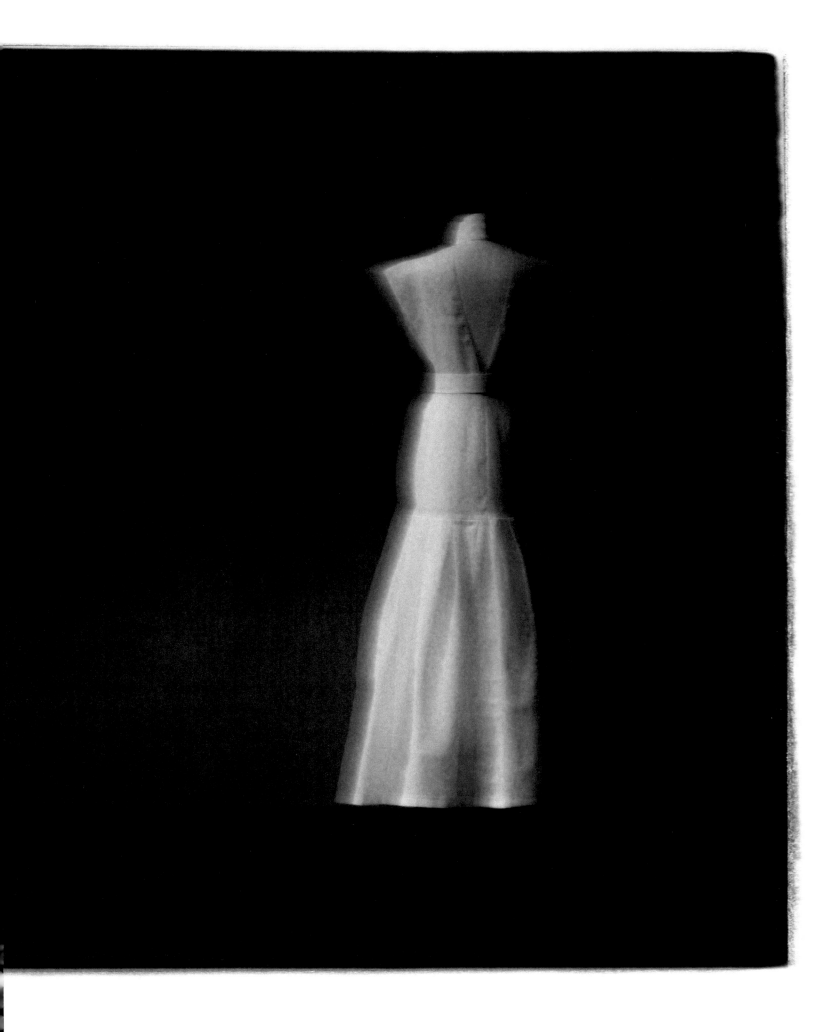

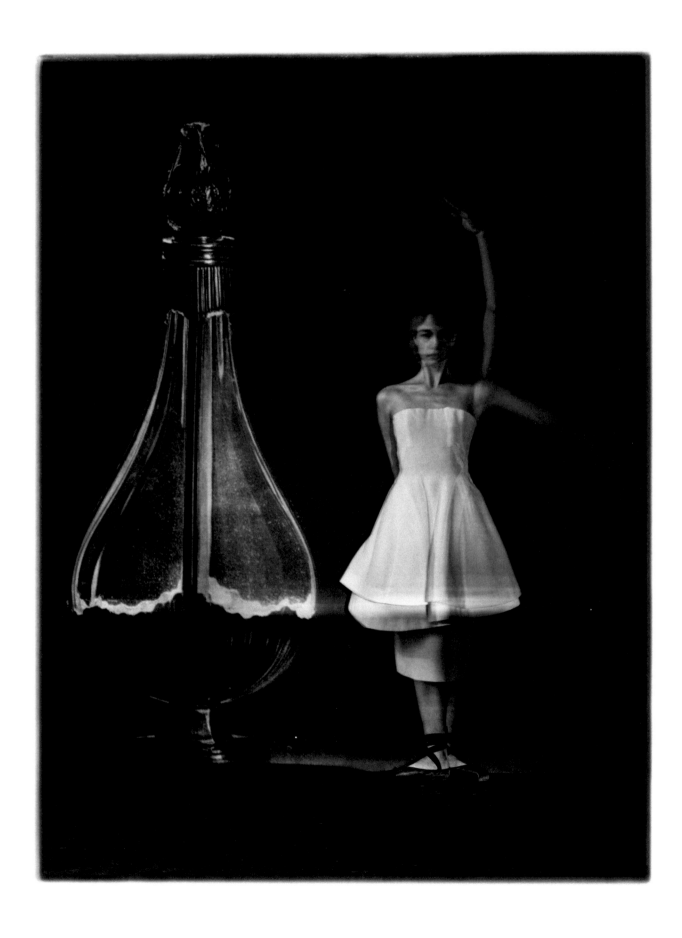

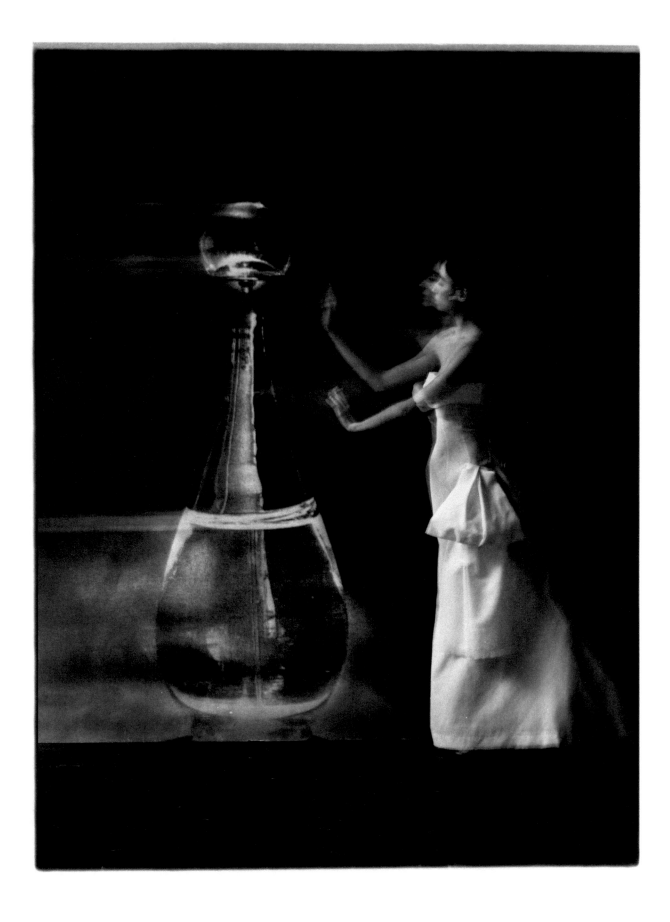

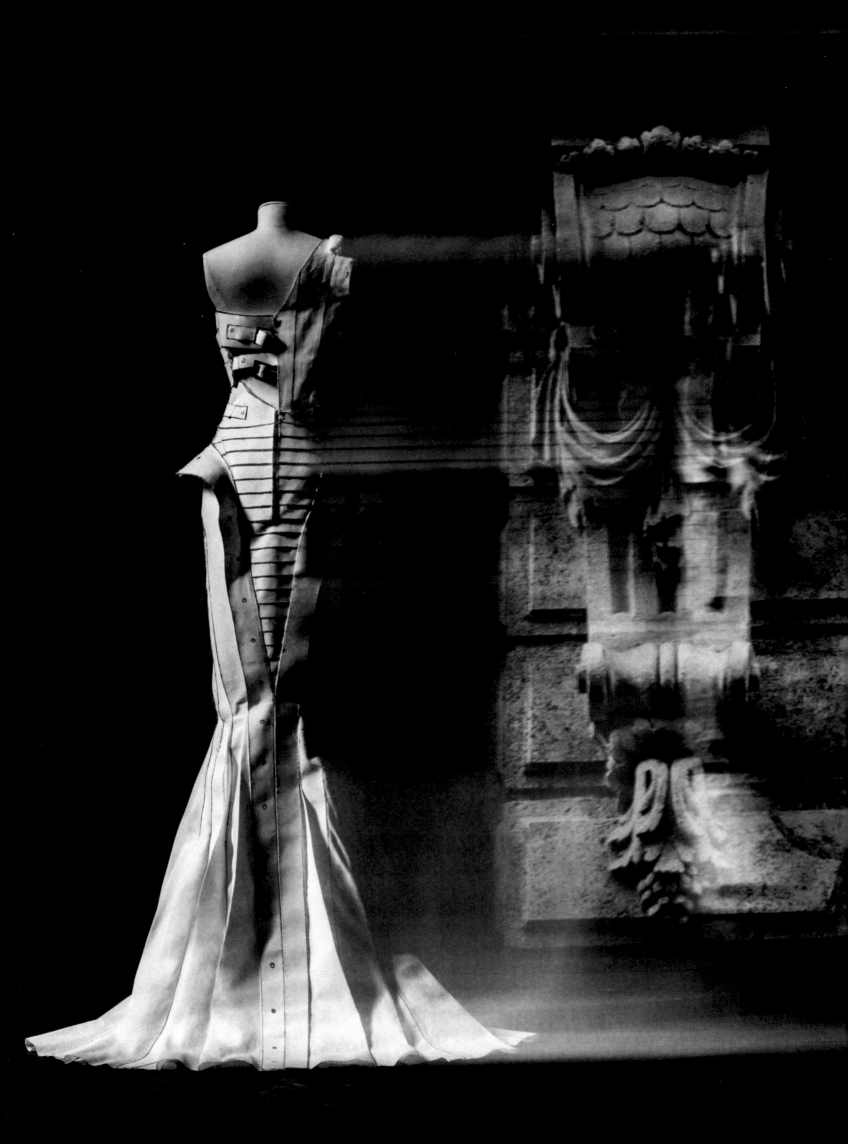

WITH ITS LINES,
ITS FULLNESS,
ITS SHADOWS,
ITS HIGHLIGHTS,
THE TOILE
IS IN FRONT OF ME.

C.D.

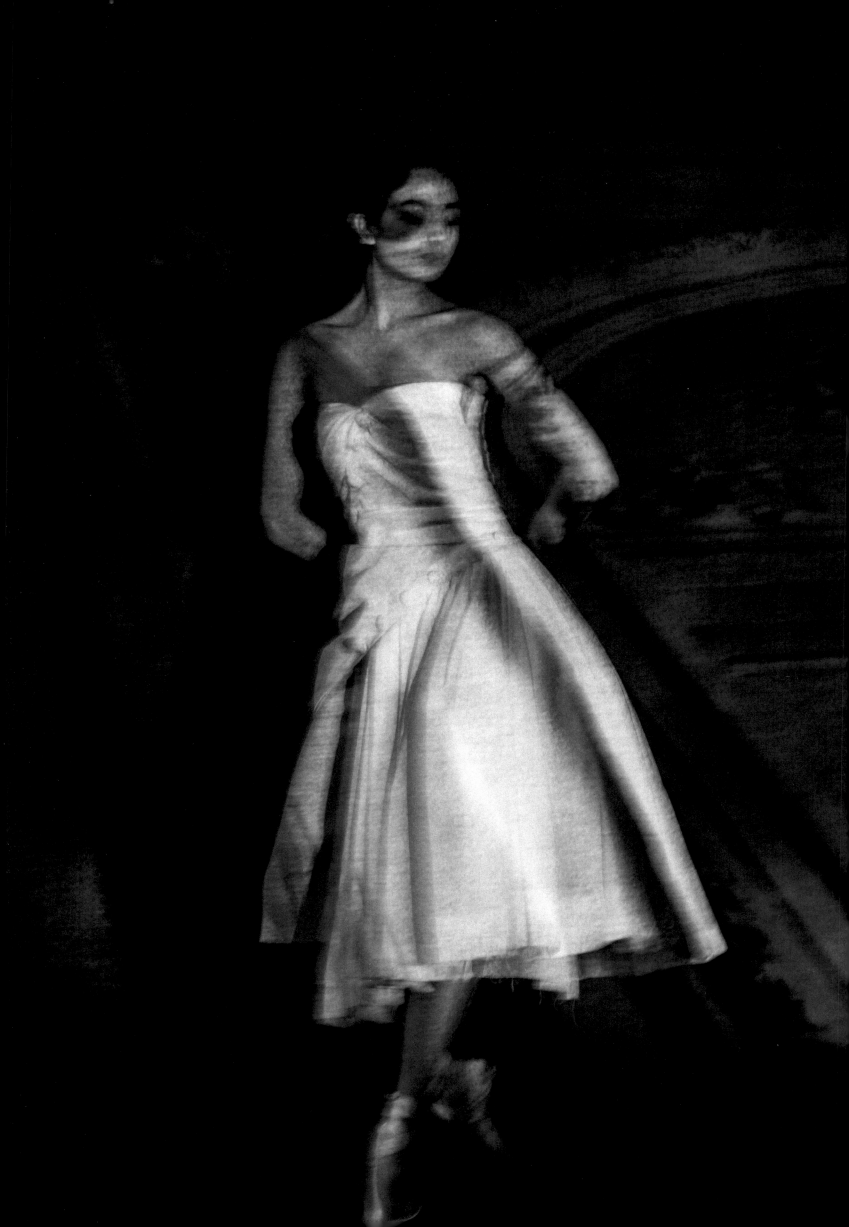

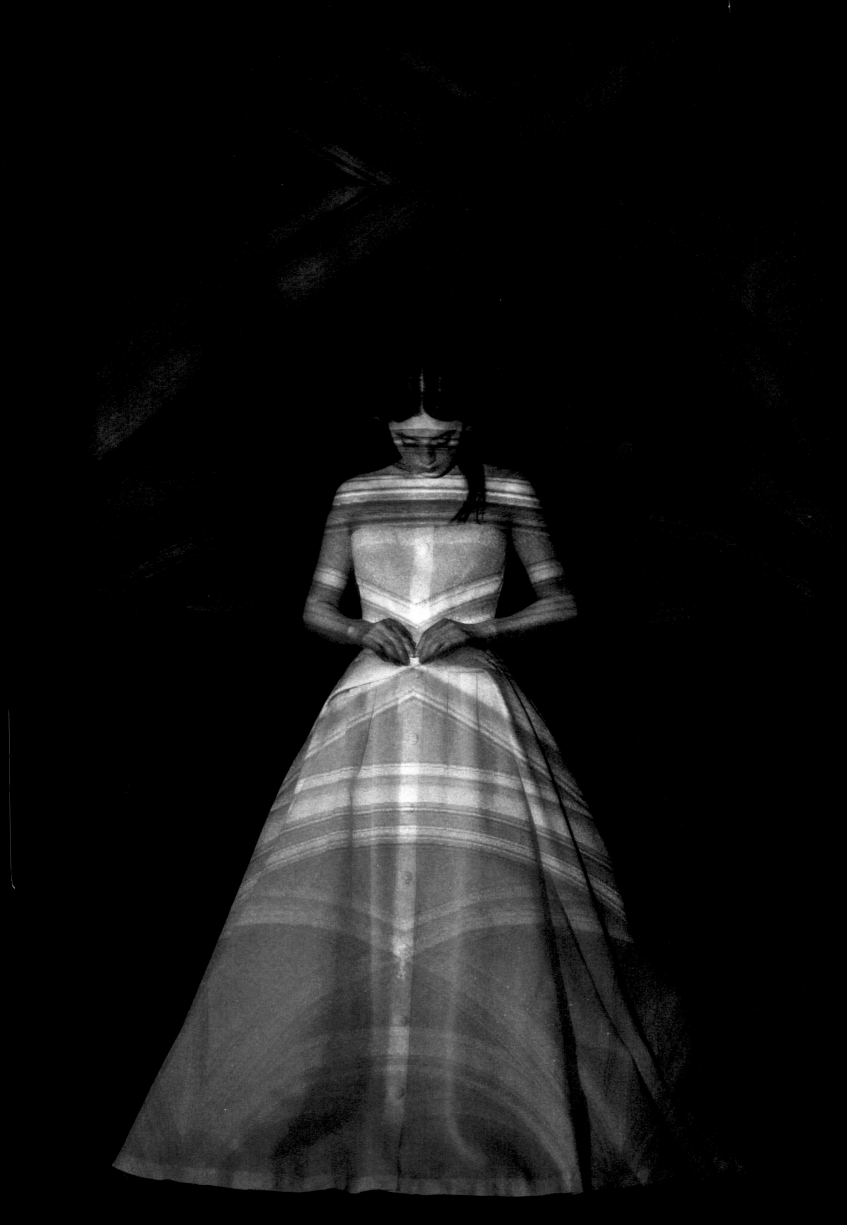

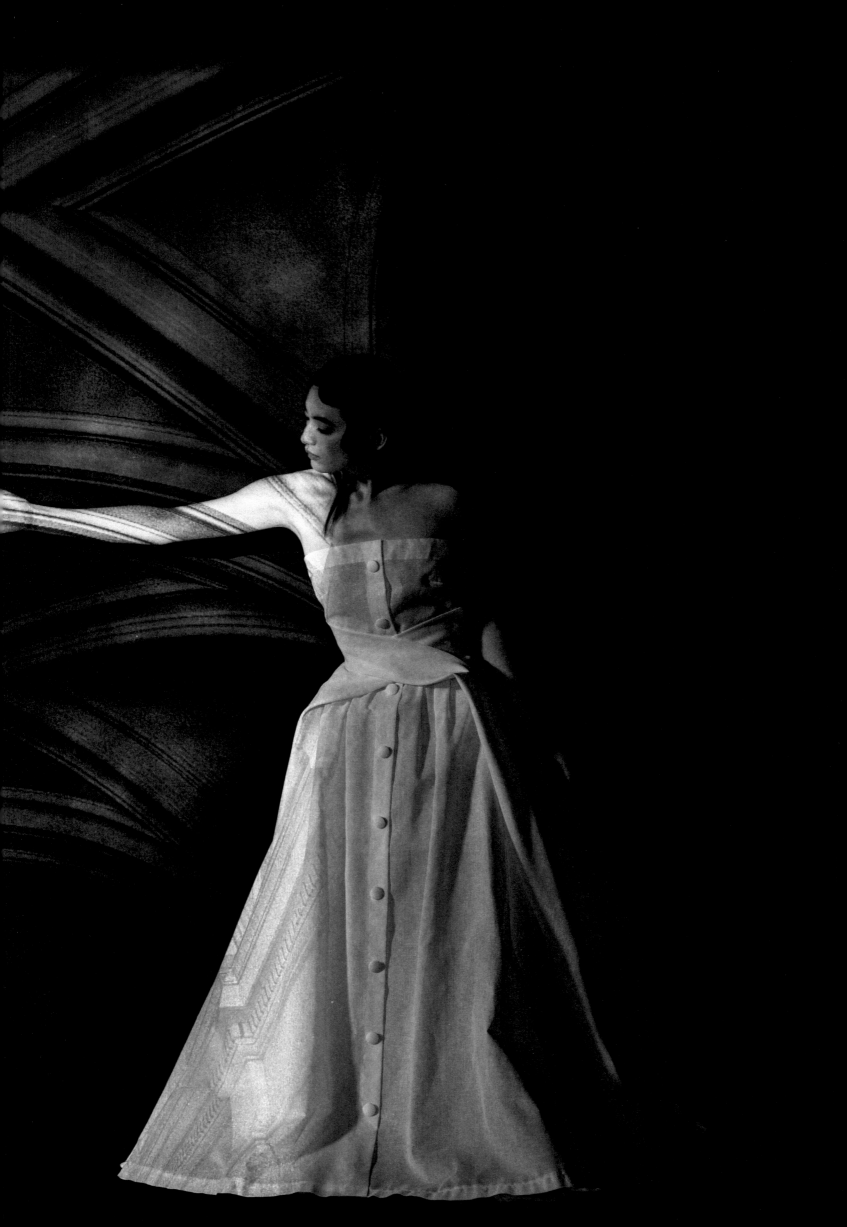

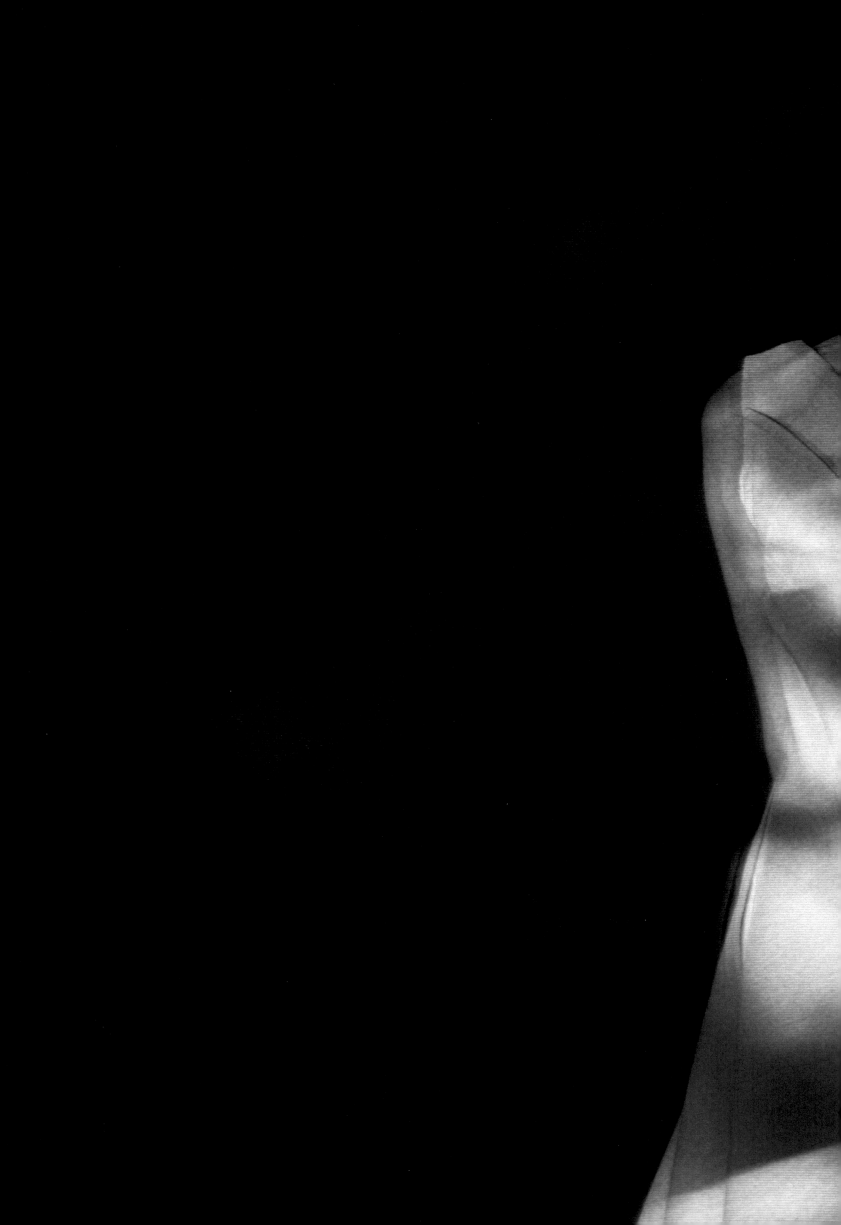

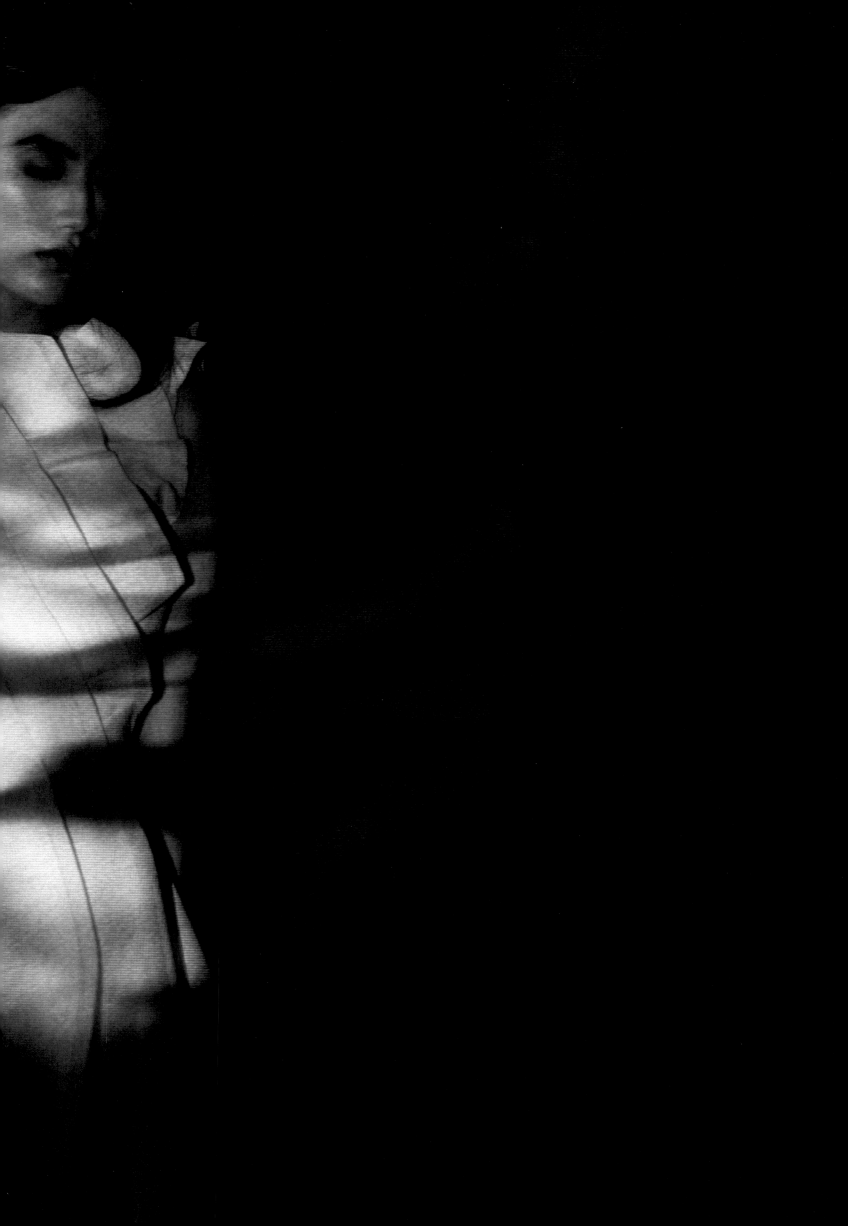

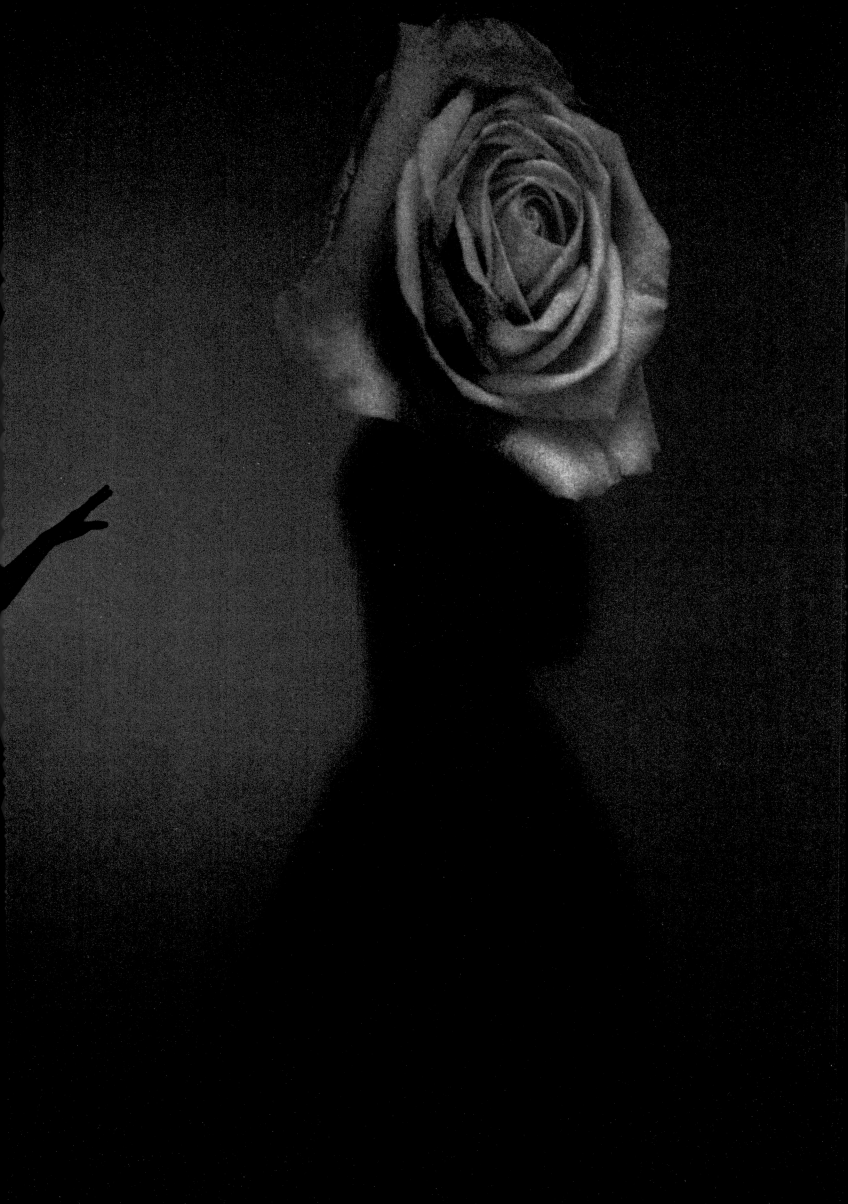

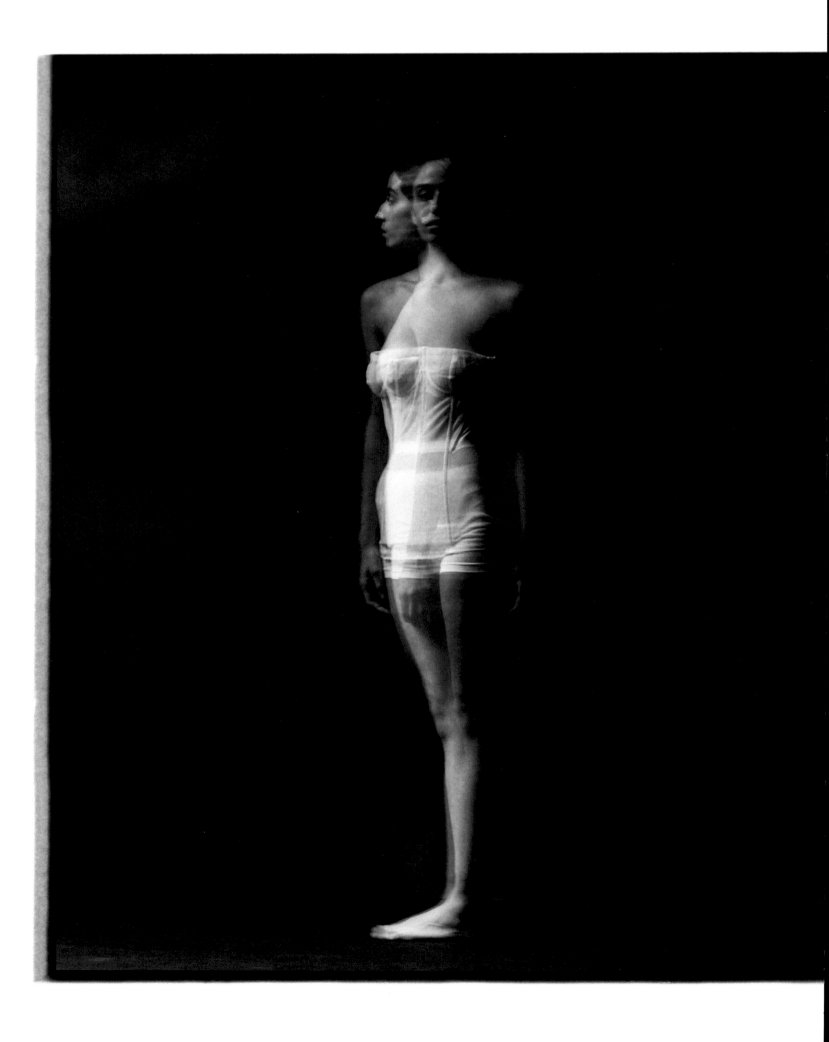

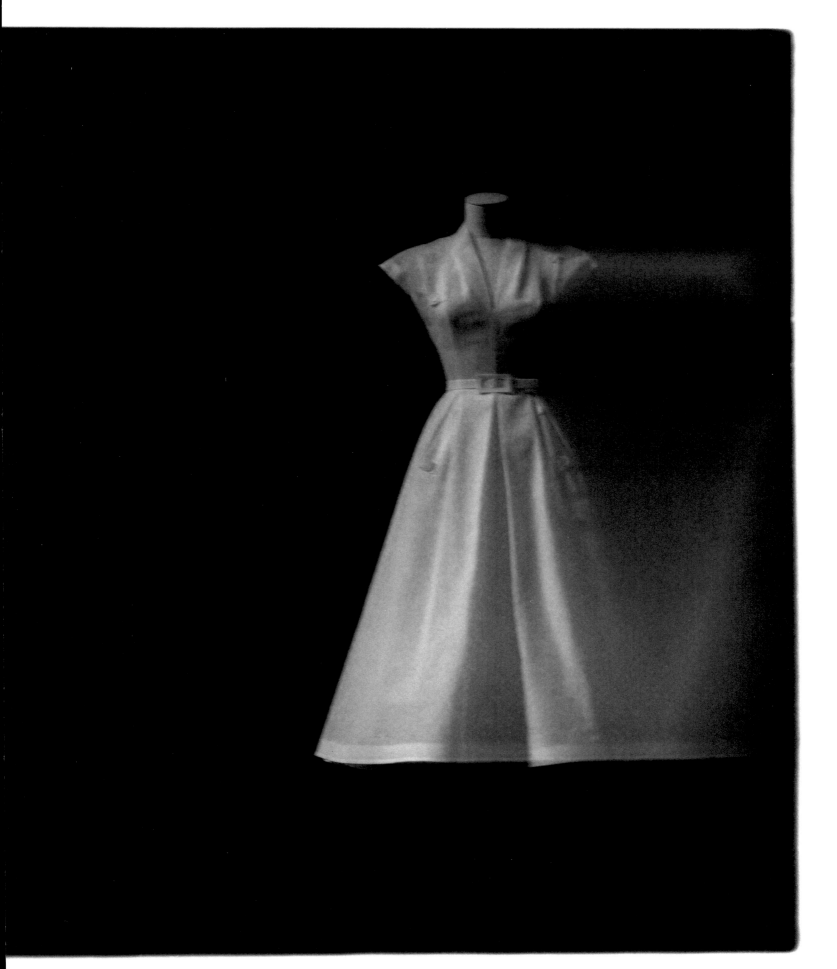

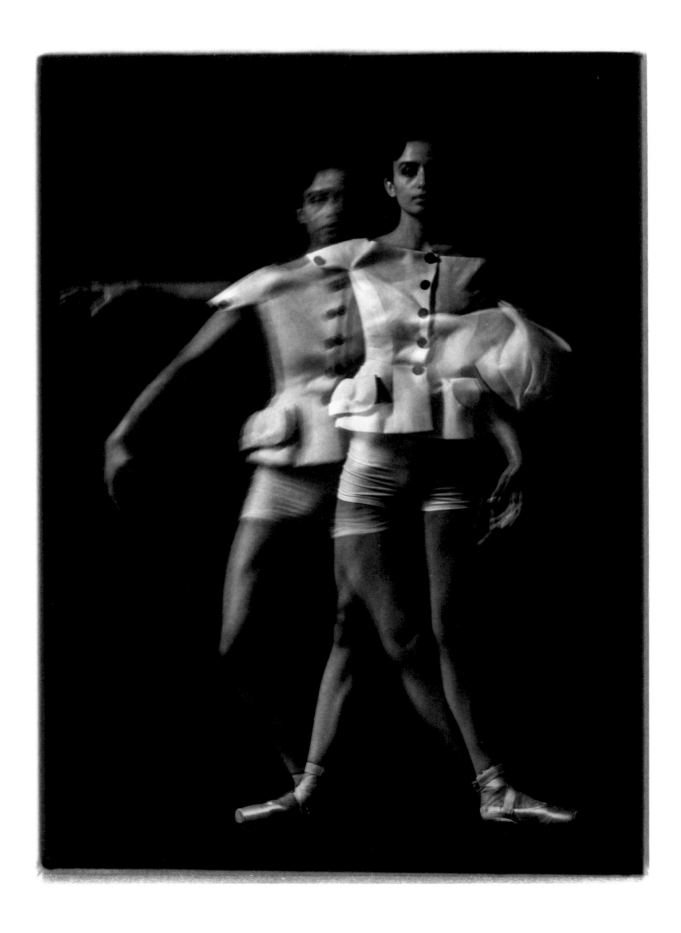

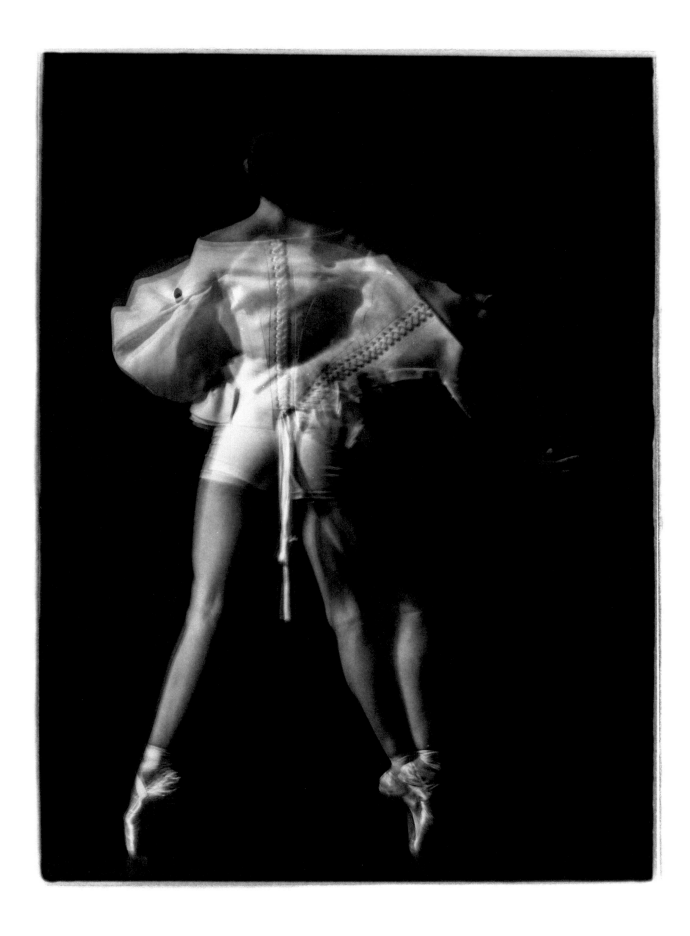

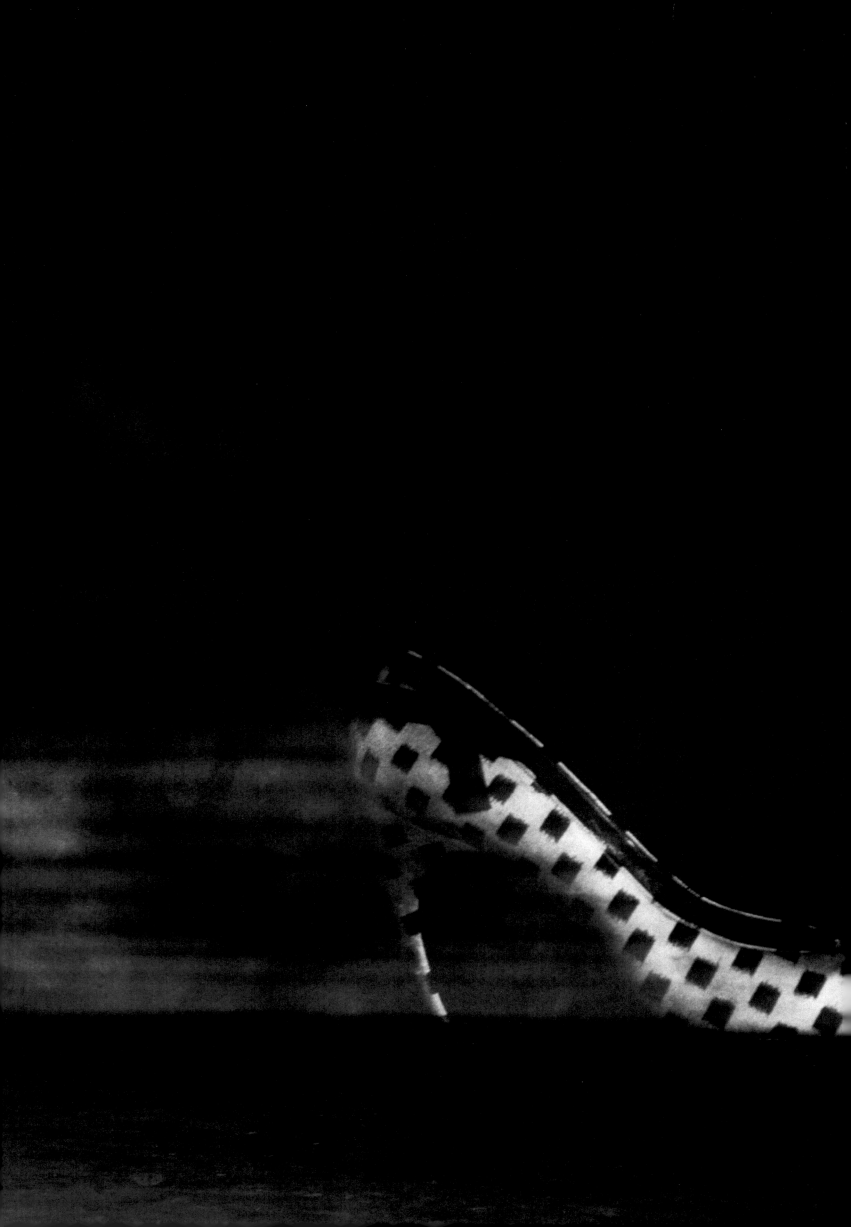

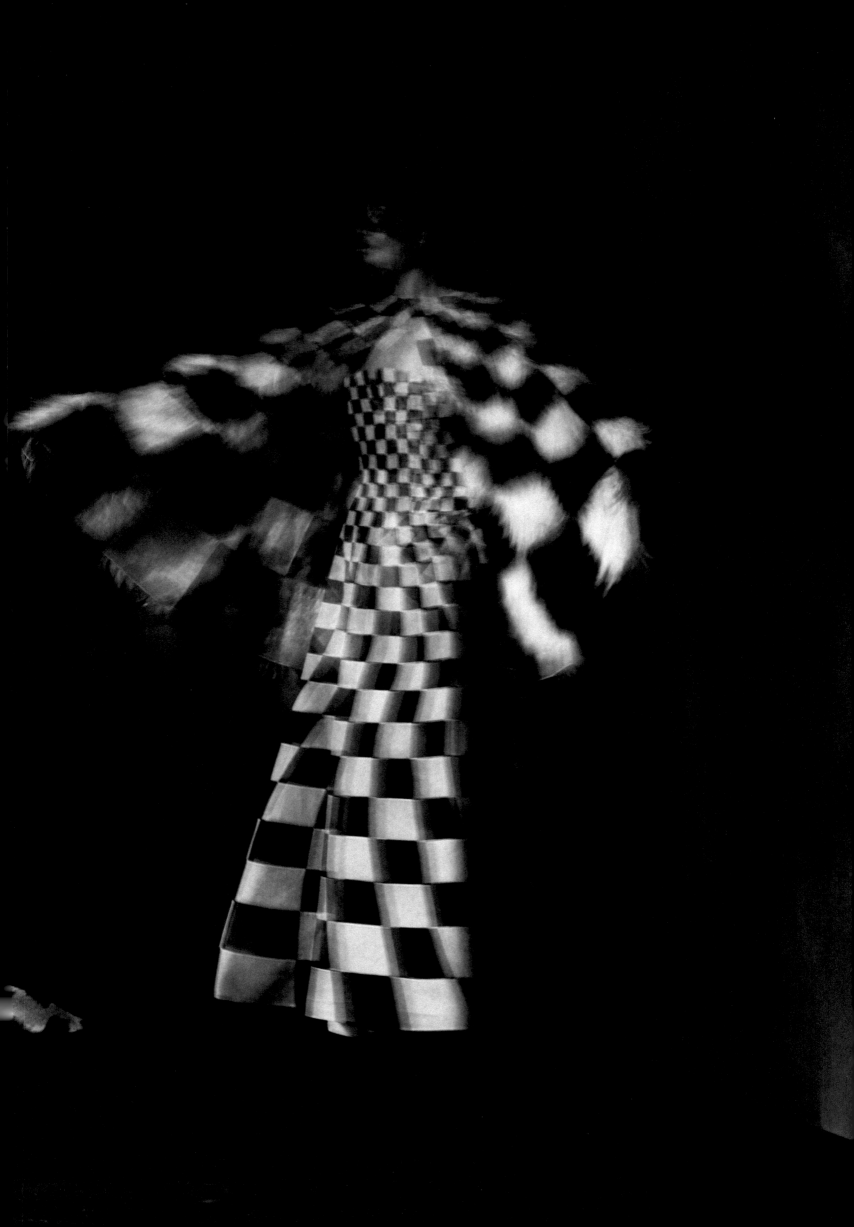

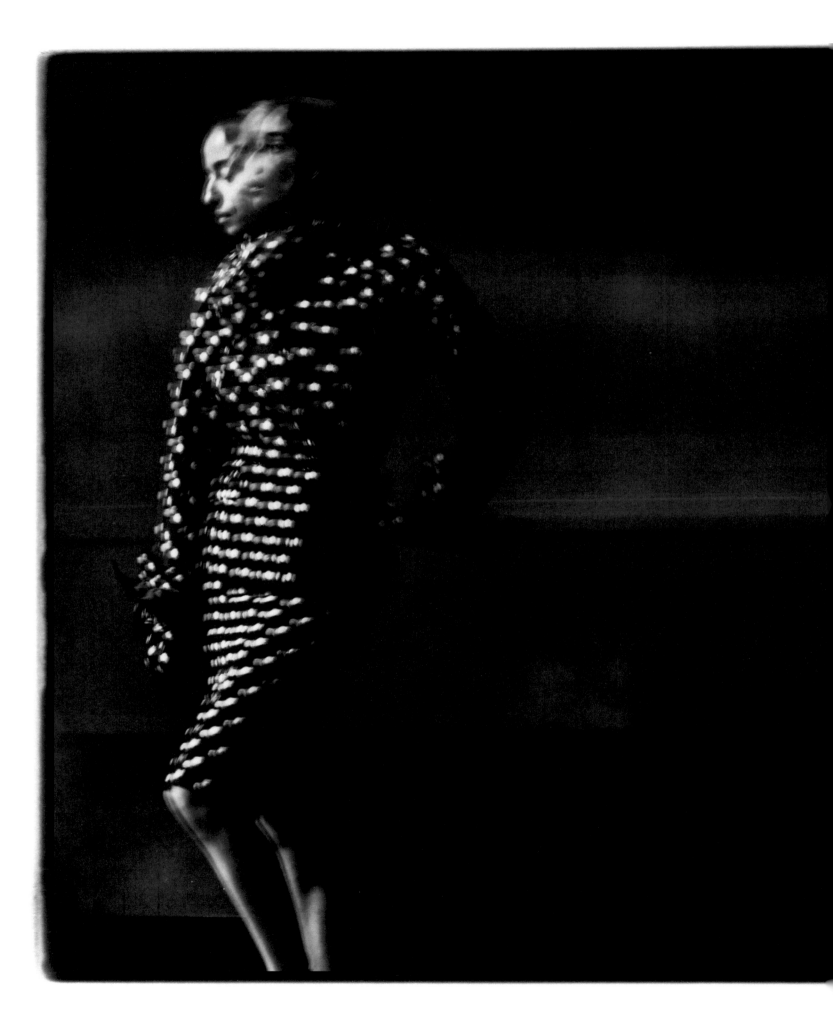

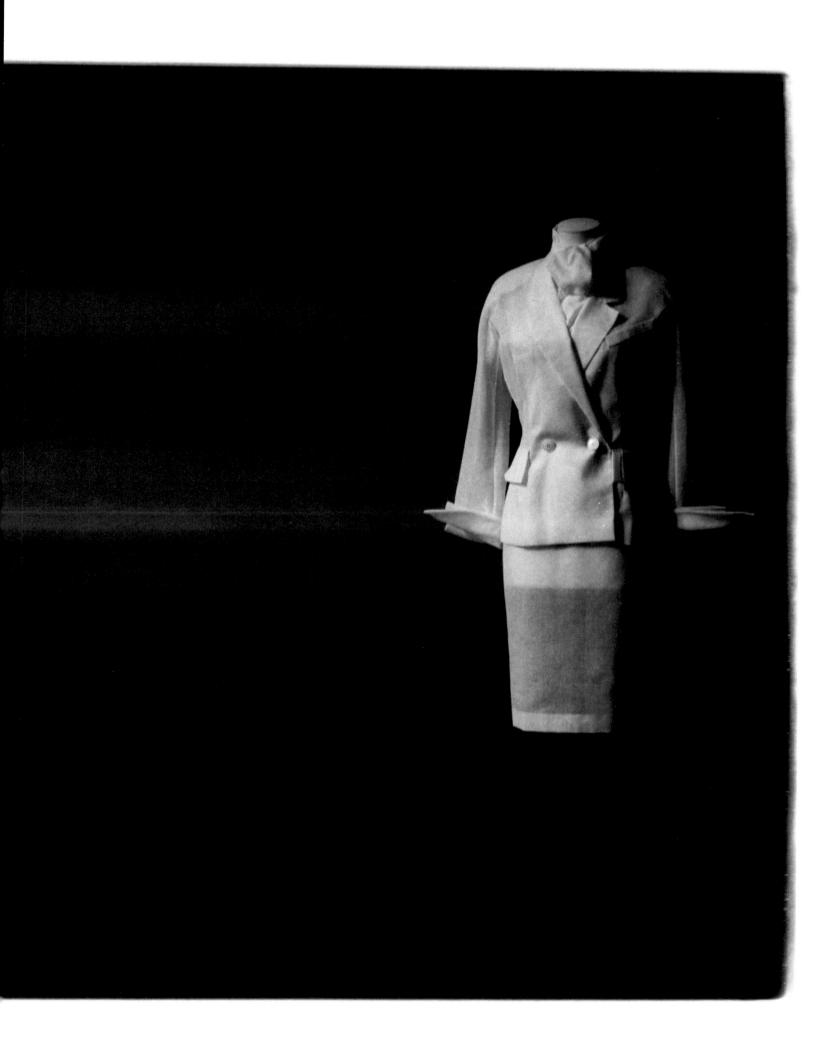

Christian DIOR

Croquis N

A SKETCH
MUST SUGGEST
MOVEMENT,
ALLURE, A GESTURE;
IT MUST BE
REDOLENT WITH LIFE.

C.D.

A SKETCH
MUST SUGGEST
MOVEMENT,
ALLURE, A GESTURE;
IT MUST BE
REDOLENT WITH LIFE.

C.D.

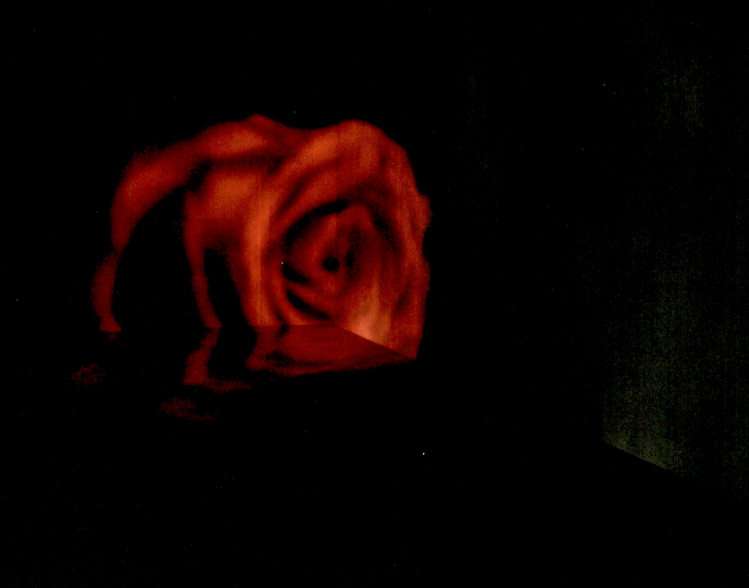

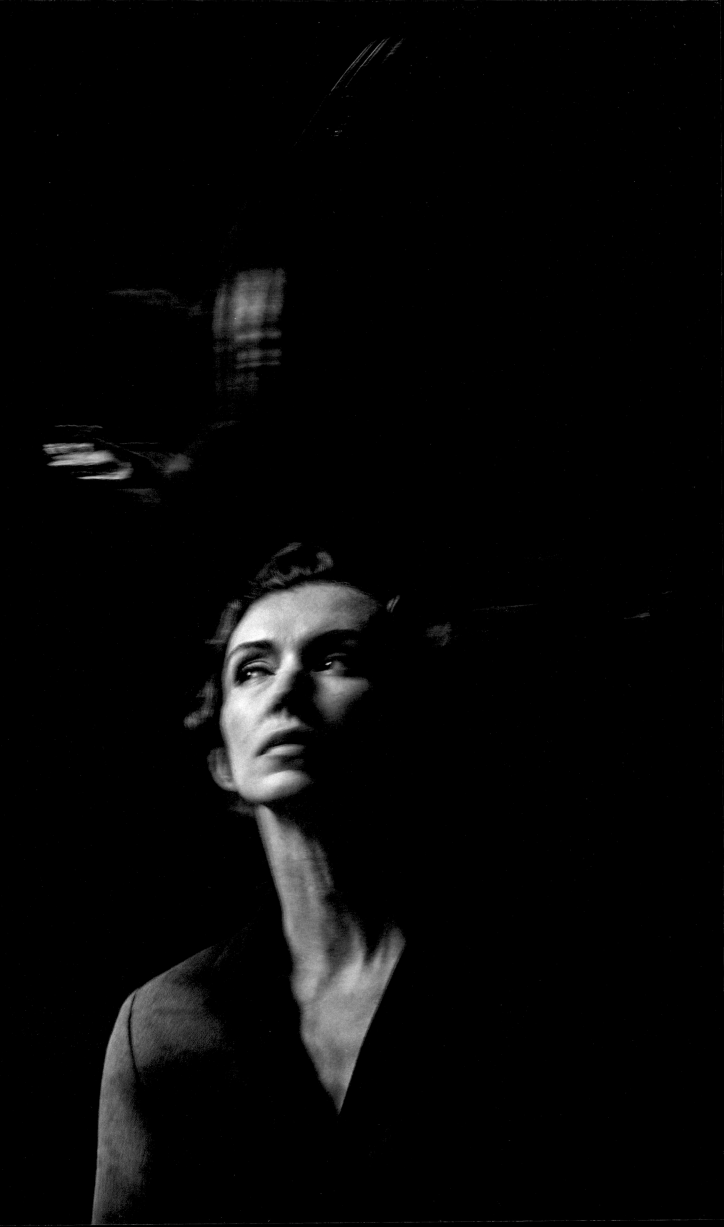

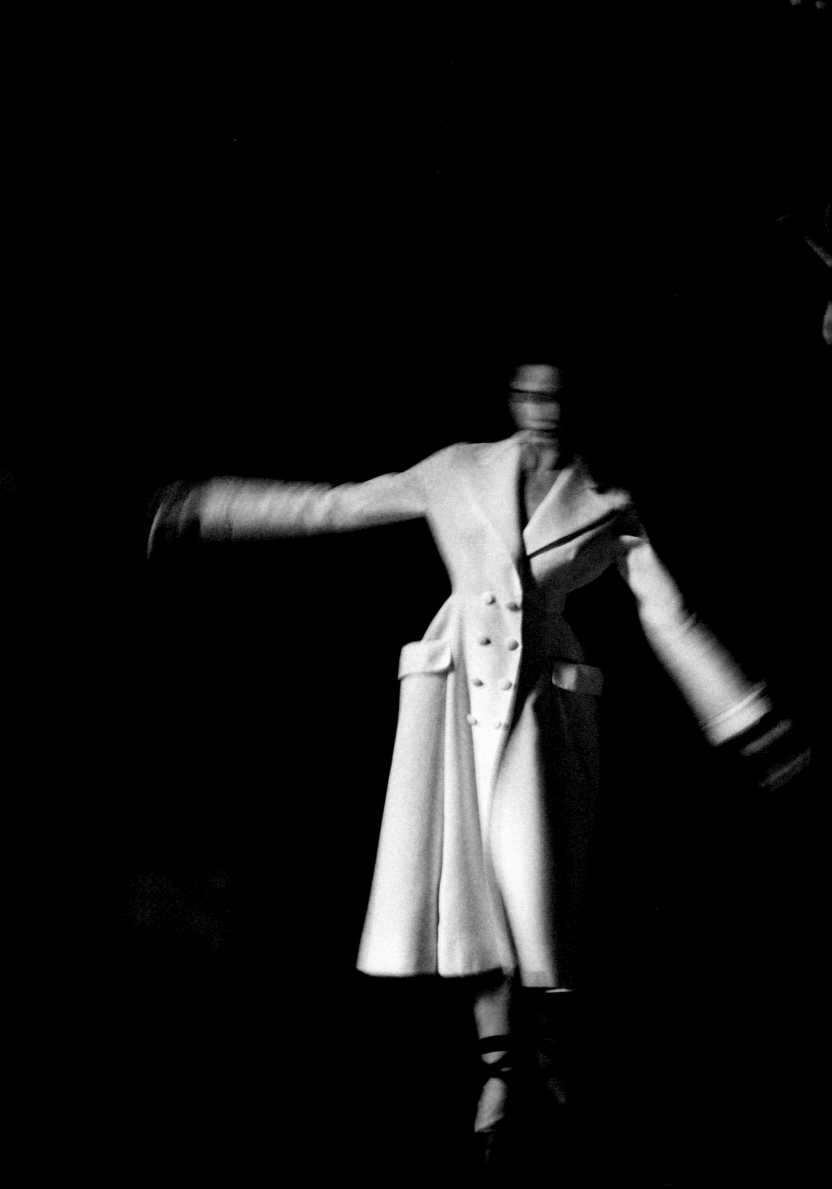

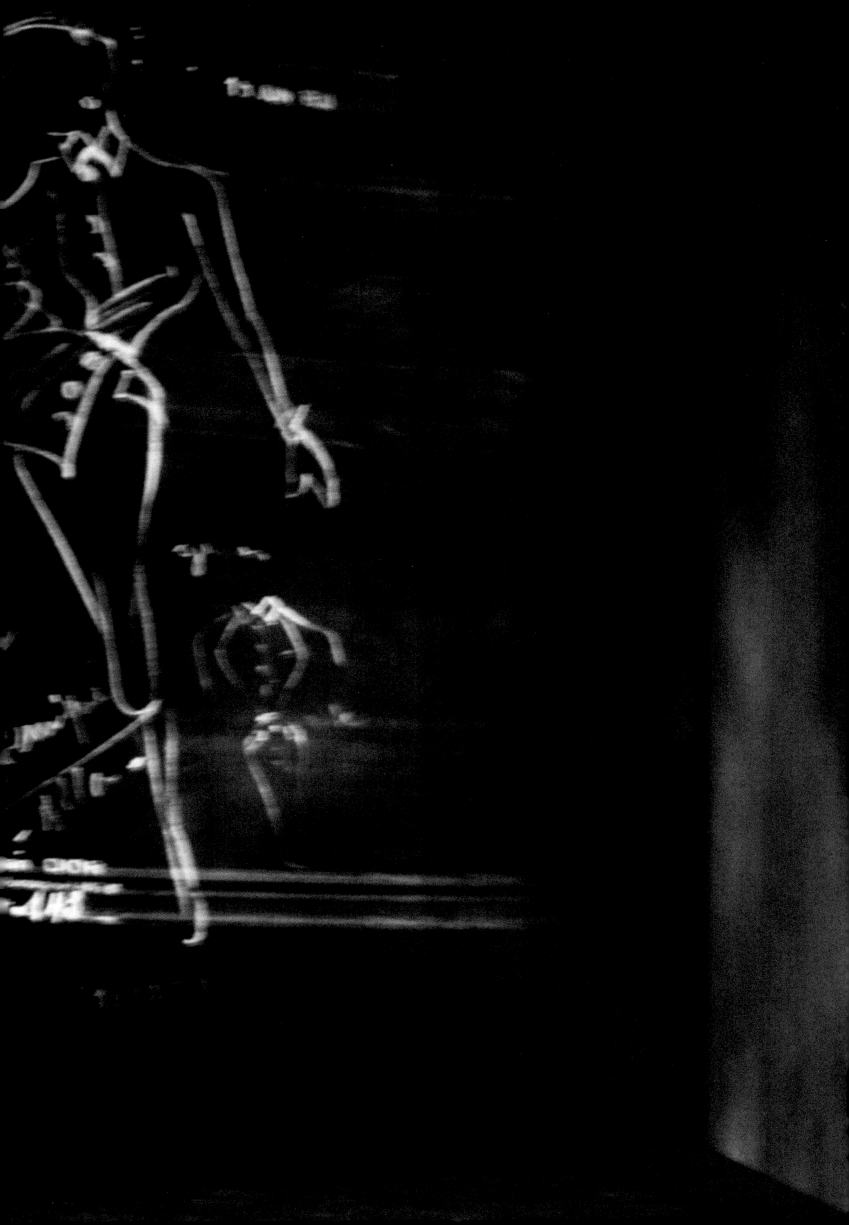

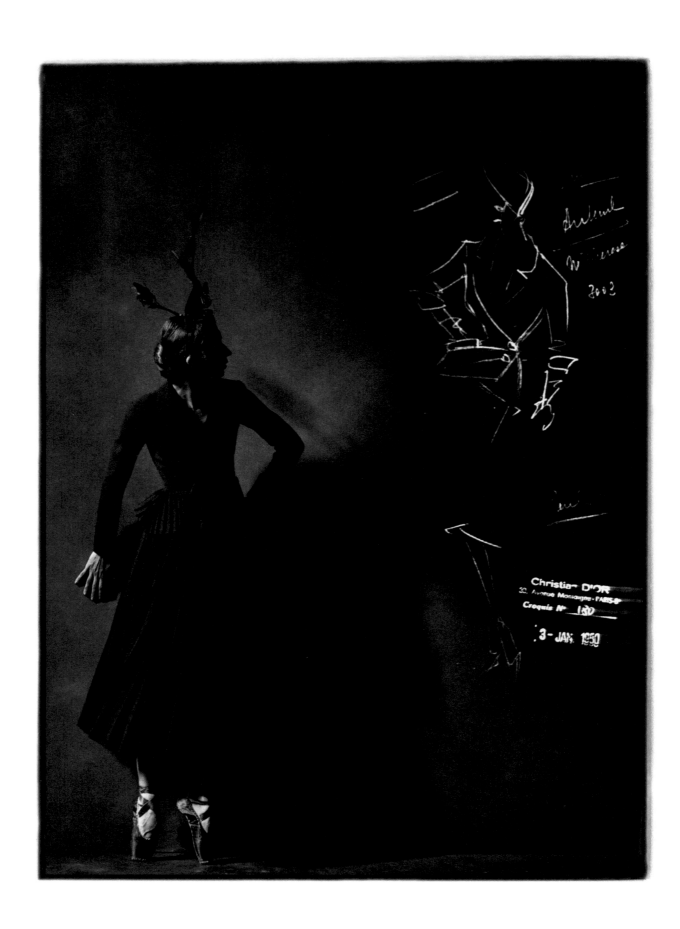

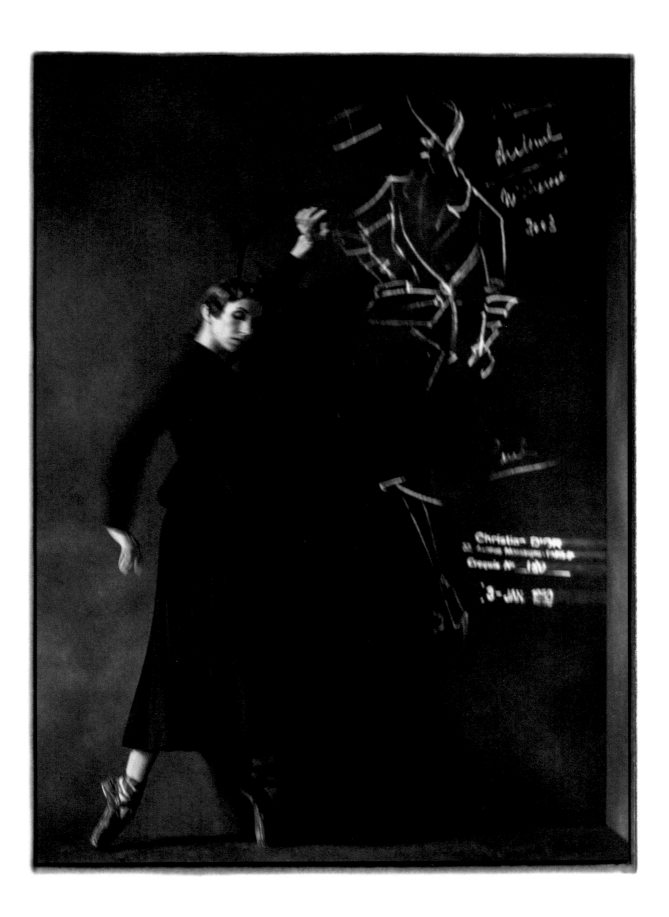

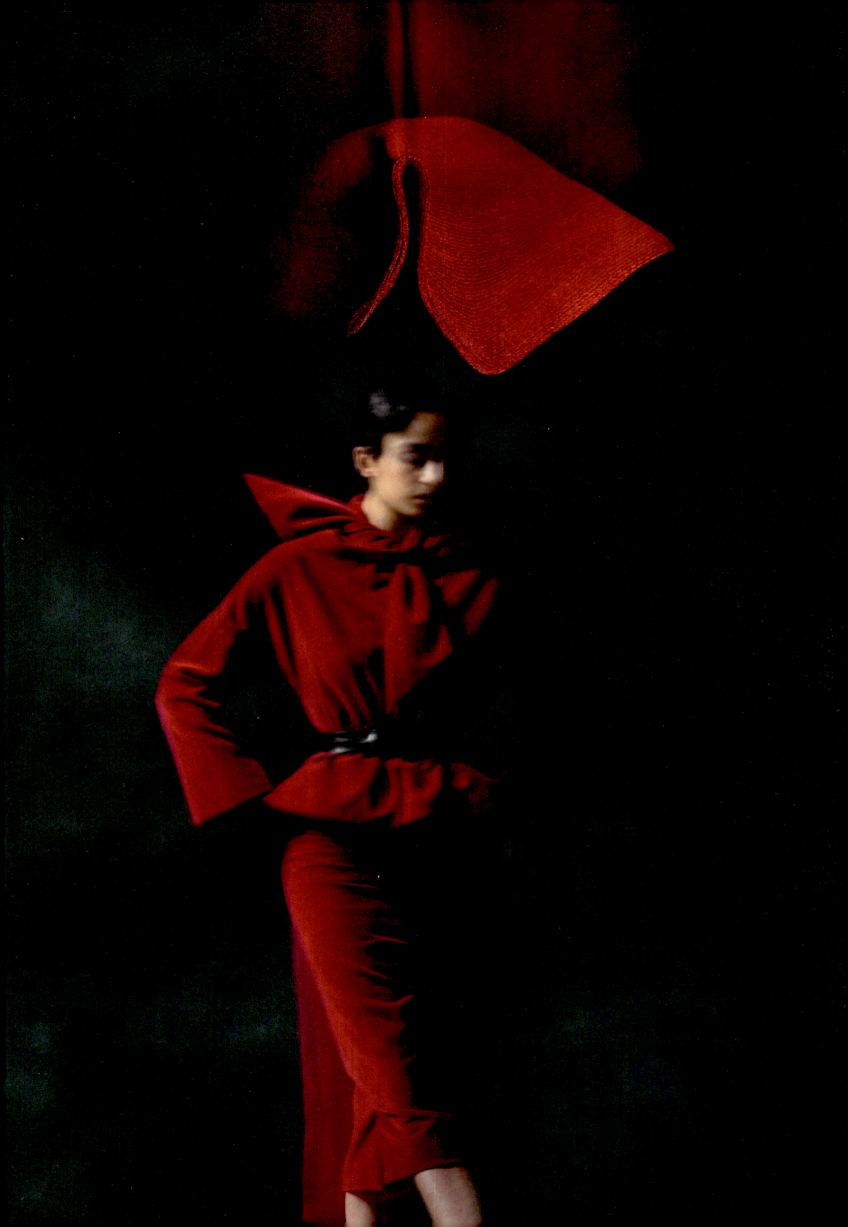

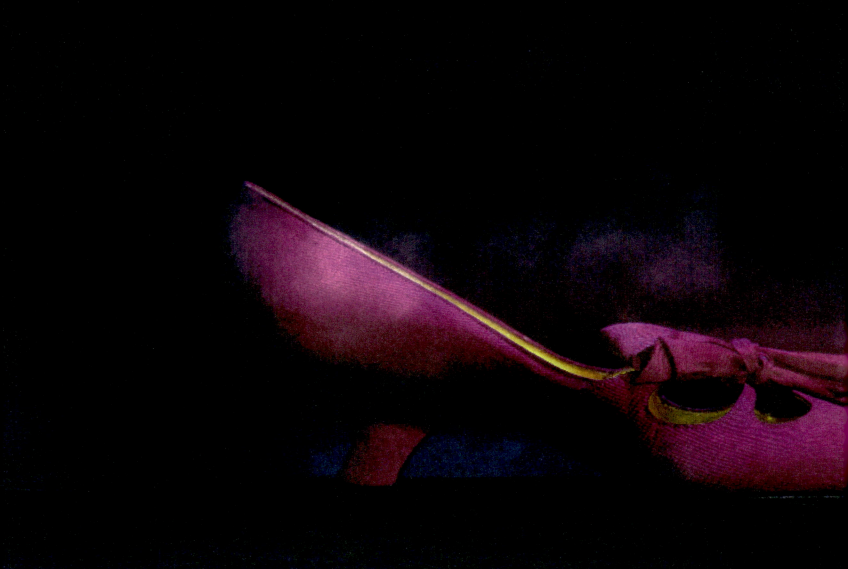

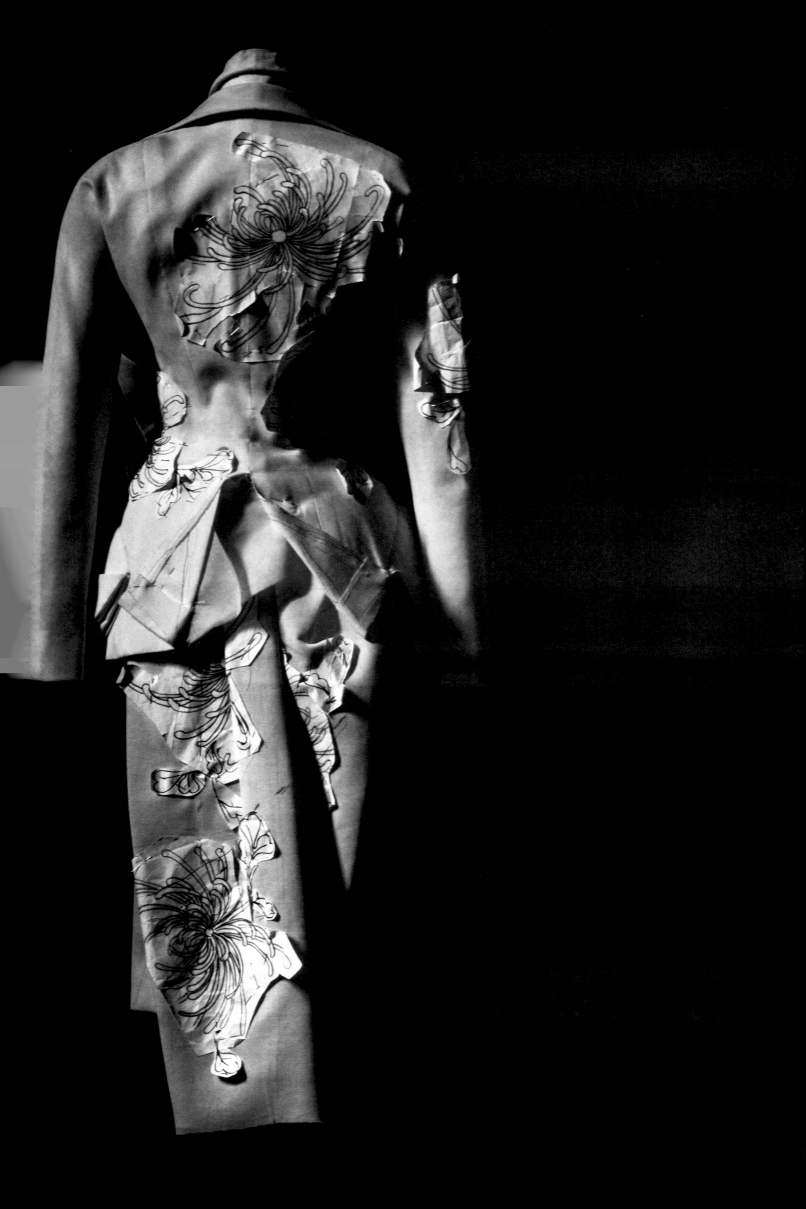

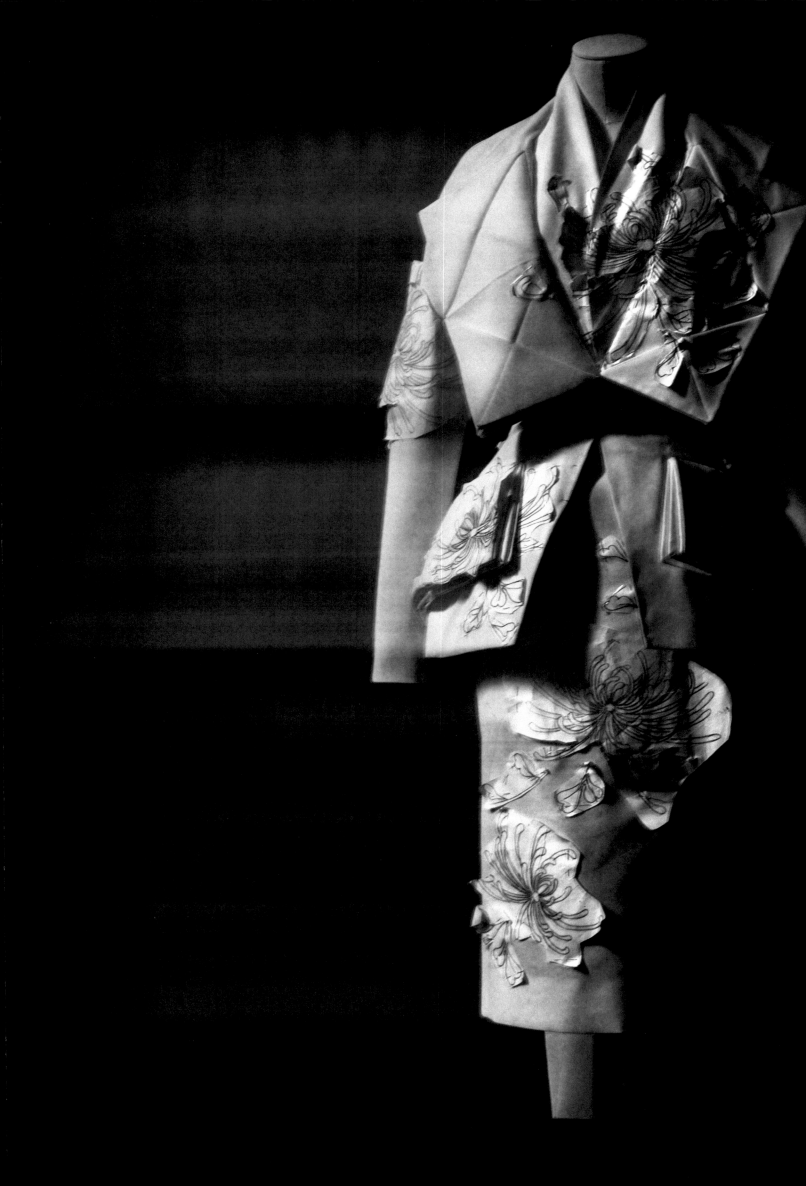

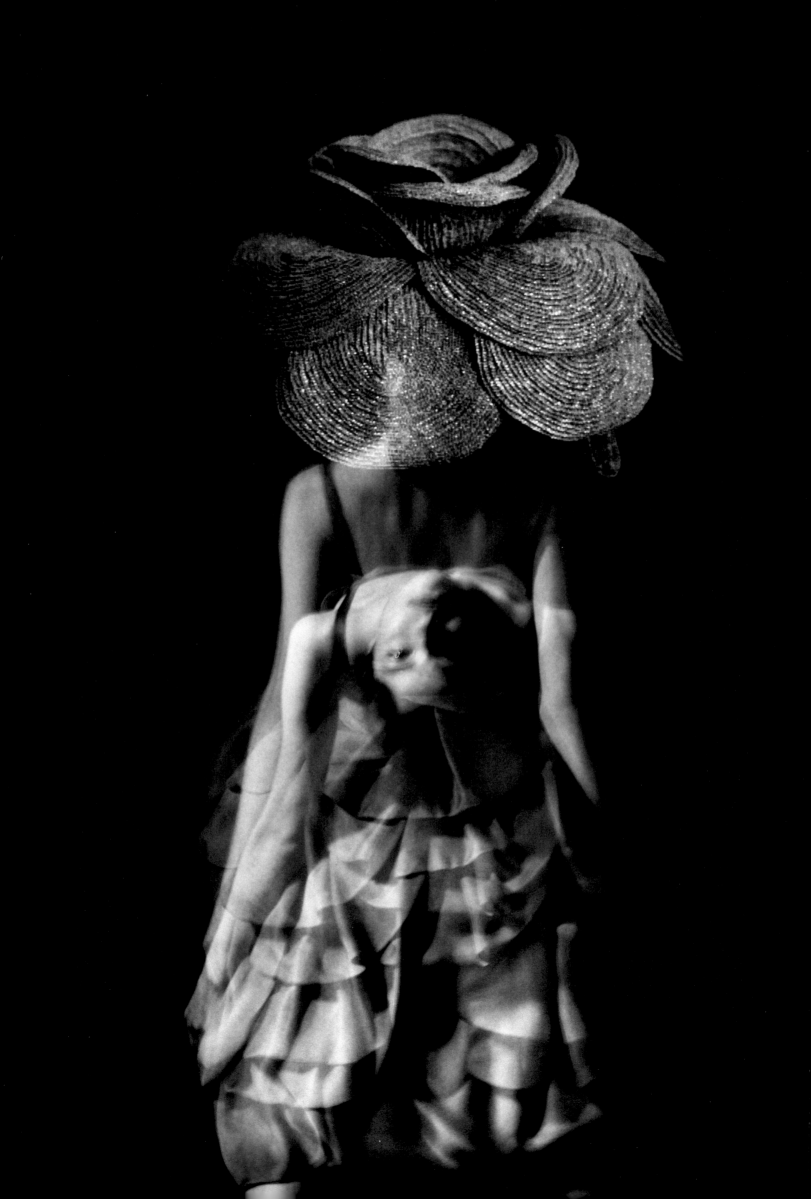

I DESIGNED
CLOTHES FOR
FLOWER-LIKE WOMEN,
WITH ROUNDED
SHOULDERS,
FULL FEMININE BUSTS,
AND HAND-SPAN
WAISTS ABOVE
ENORMOUS
SPREADING SKIRTS.

C.D.

A DESIGNED
CLOTHES FOR
FLOWER-LIKE WOMEN,
WITH ROUNDED
SHOULDERS,
FULL FEMININE BUSTS,
AND HAND-SPAN
WAISTS ABOVE
ENORMOUS
SPREADING SKIRTS.

C. D.

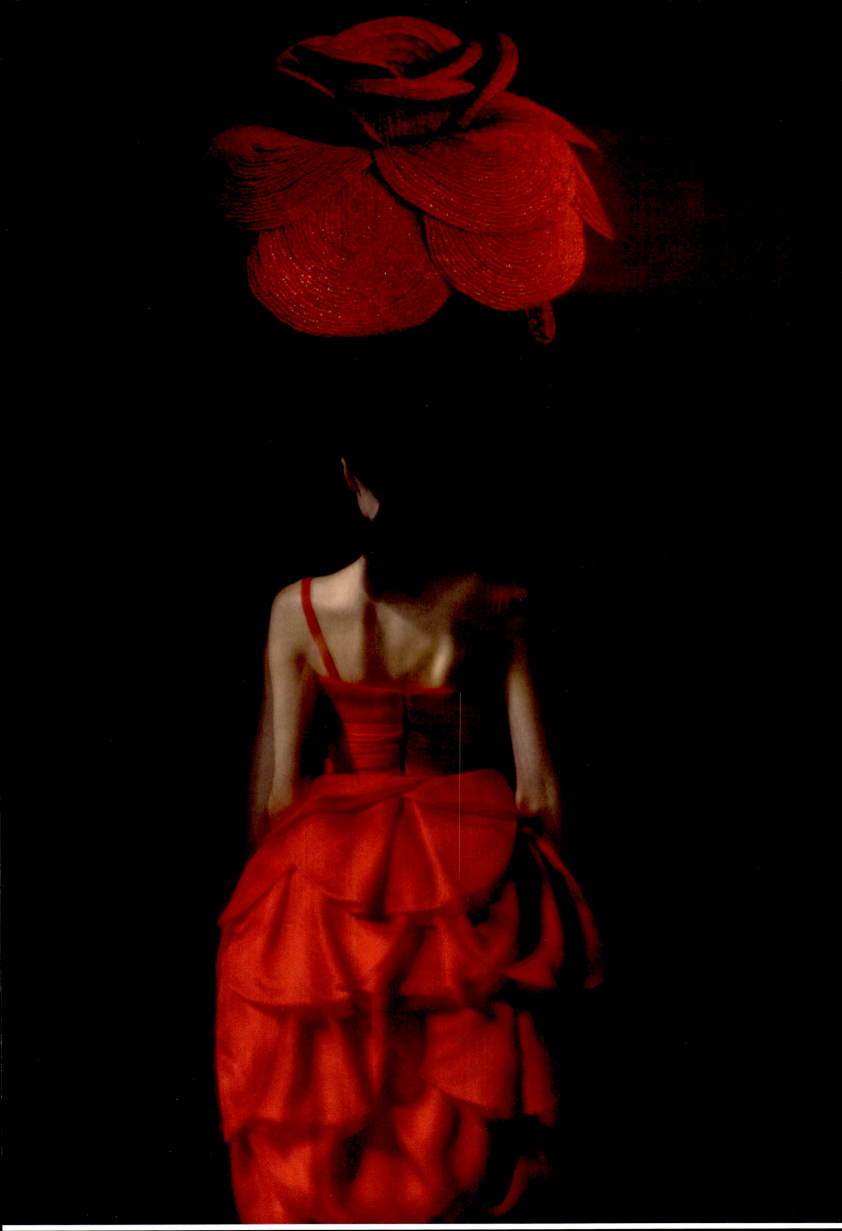

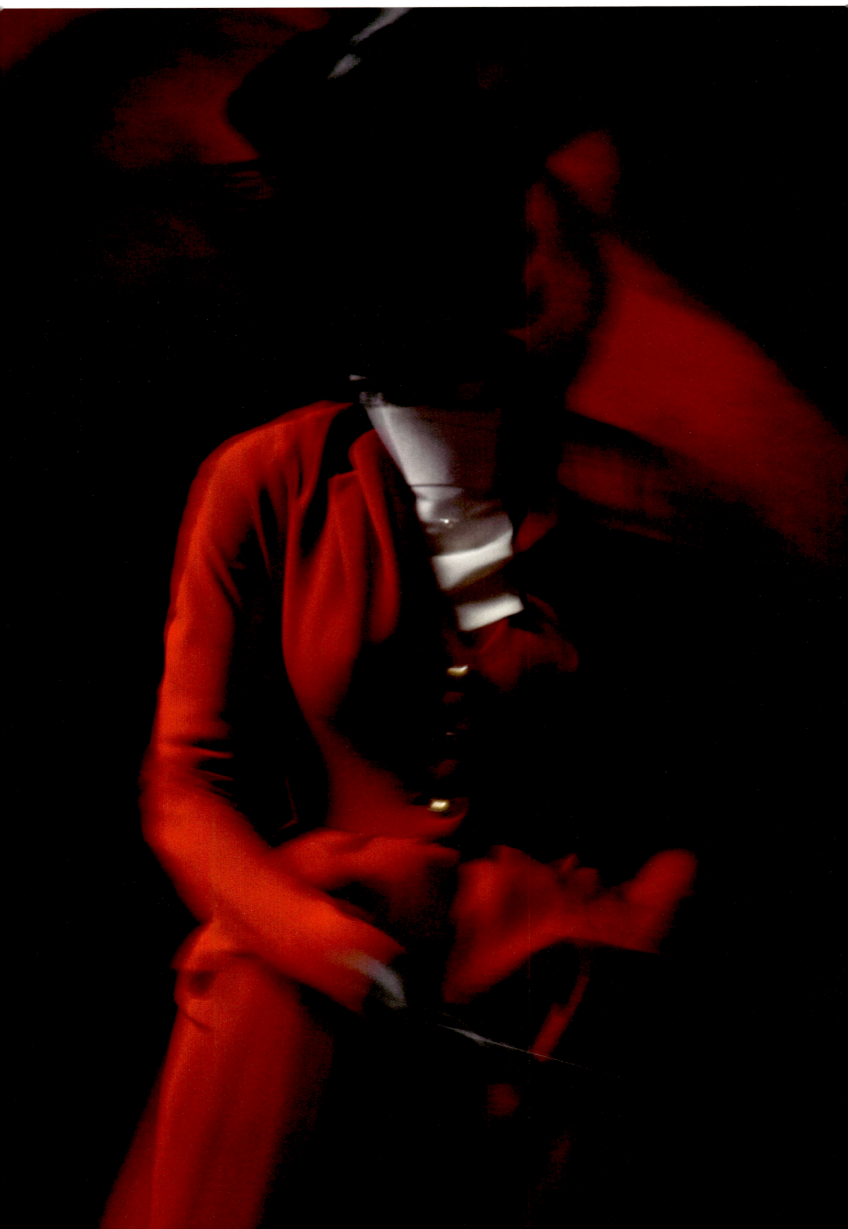

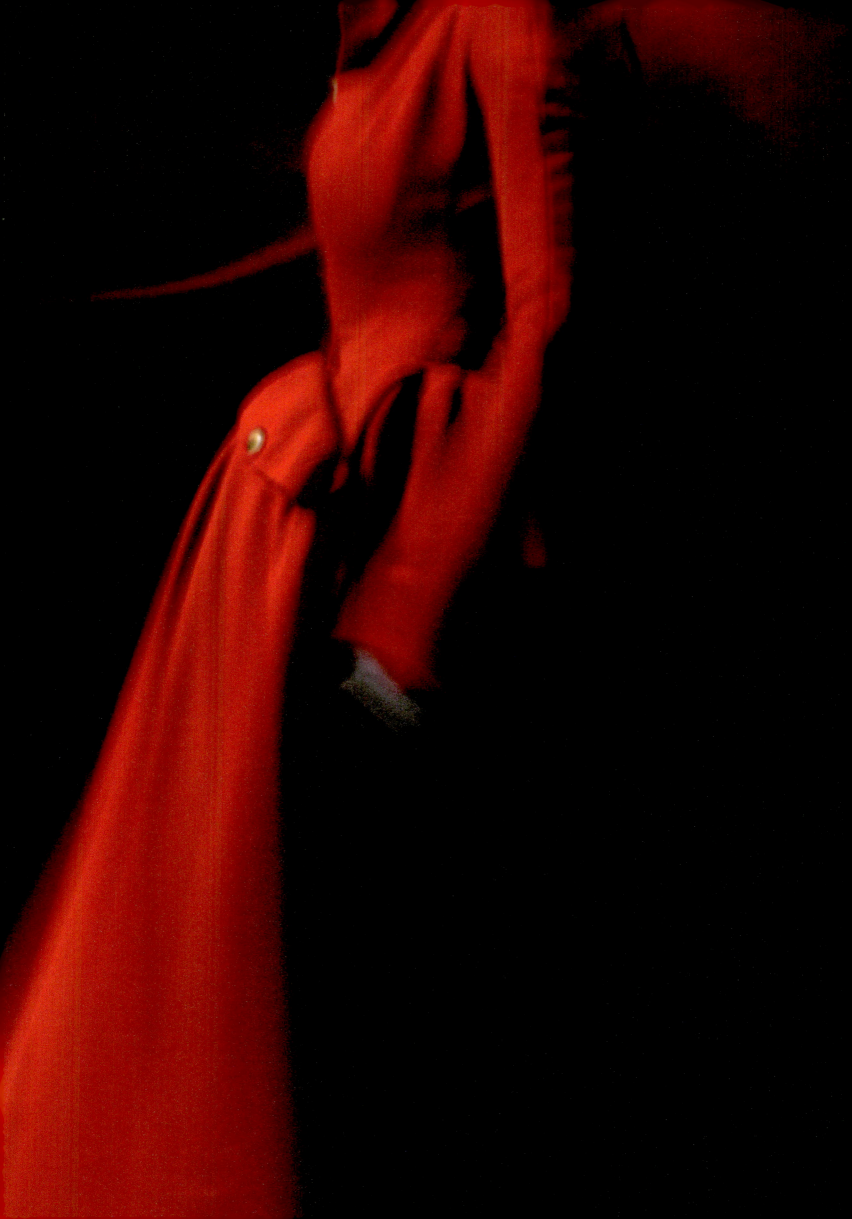

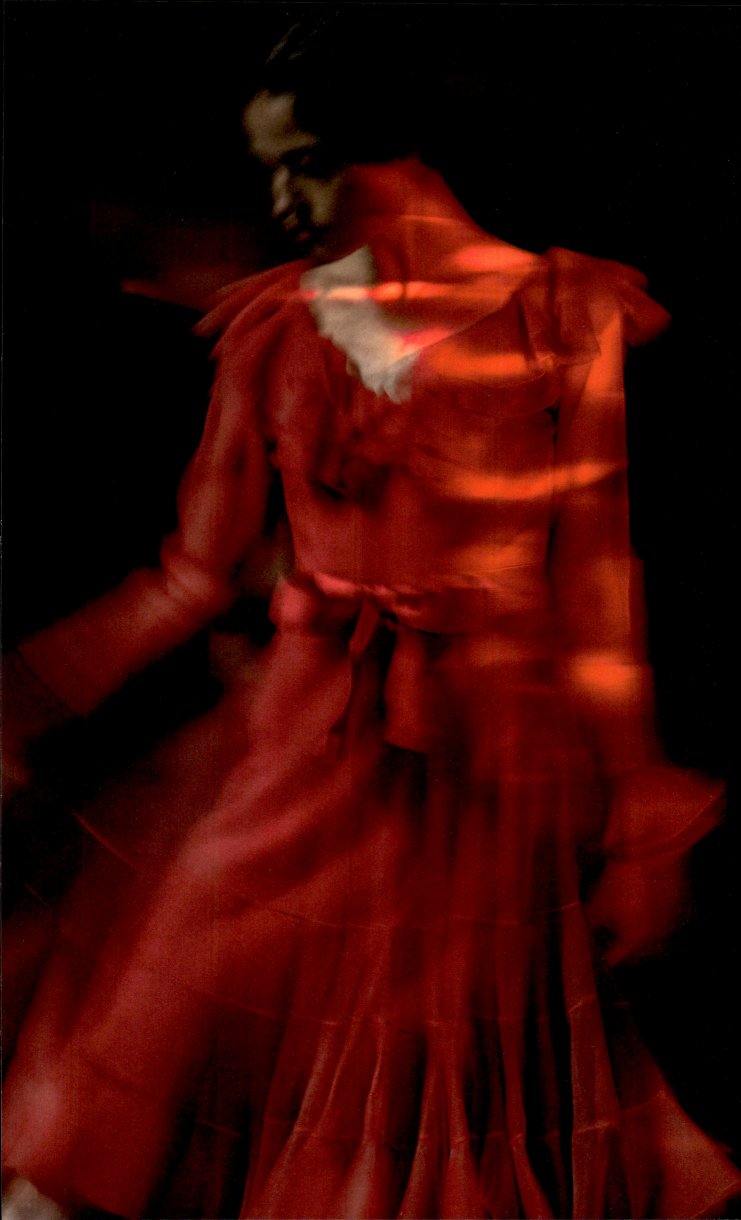

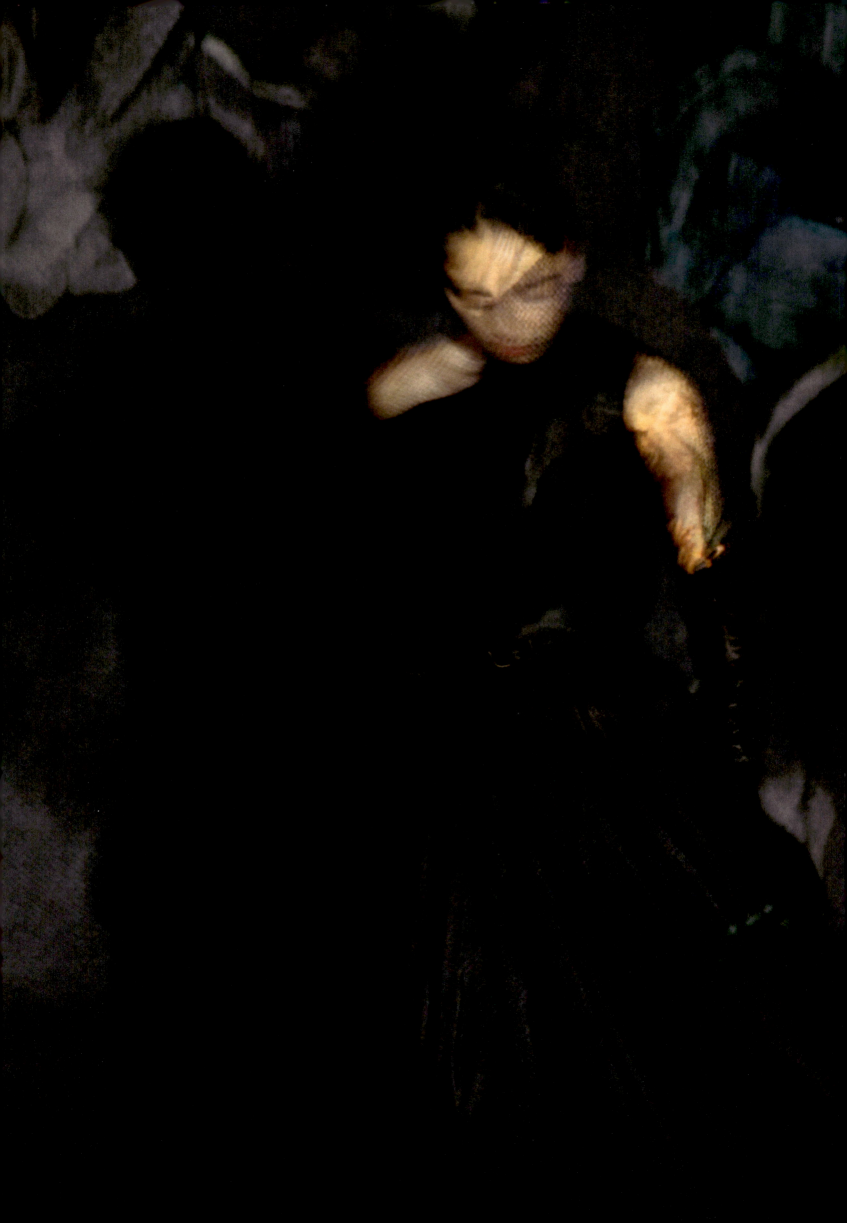

A DRESS
AS I DESIGN IT
IS AN EPHEMERAL
ARCHITECTURE
DEDICATED
TO CELEBRATING
THE PROPORTIONS
OF THE
FEMALE BODY

C.D.

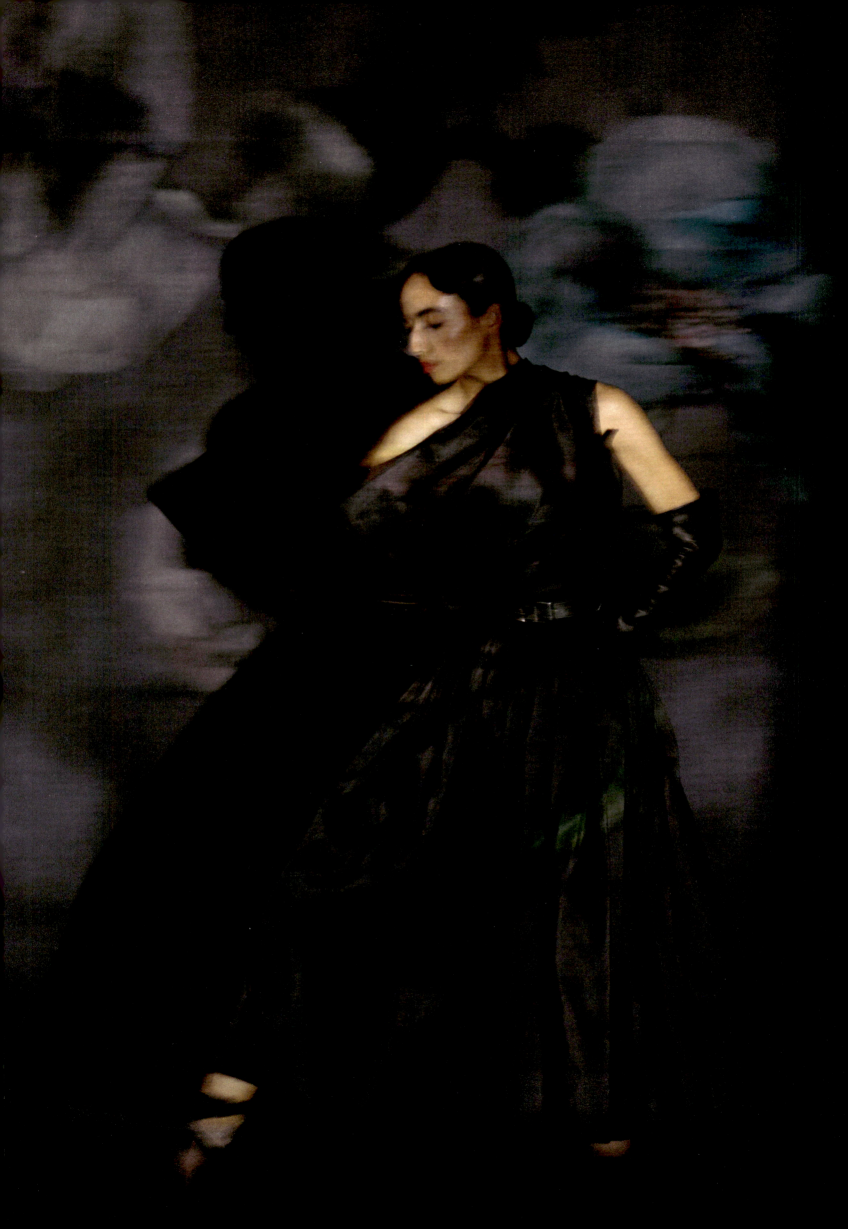

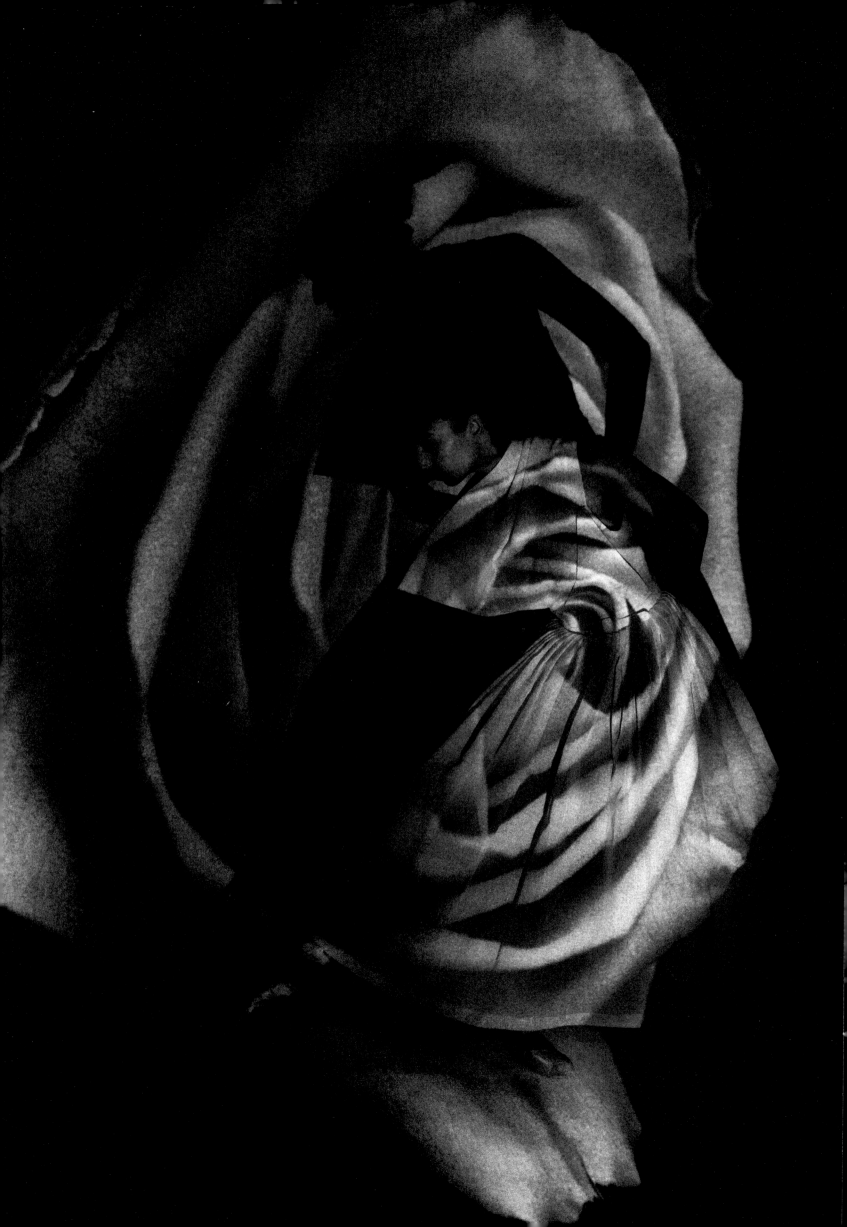

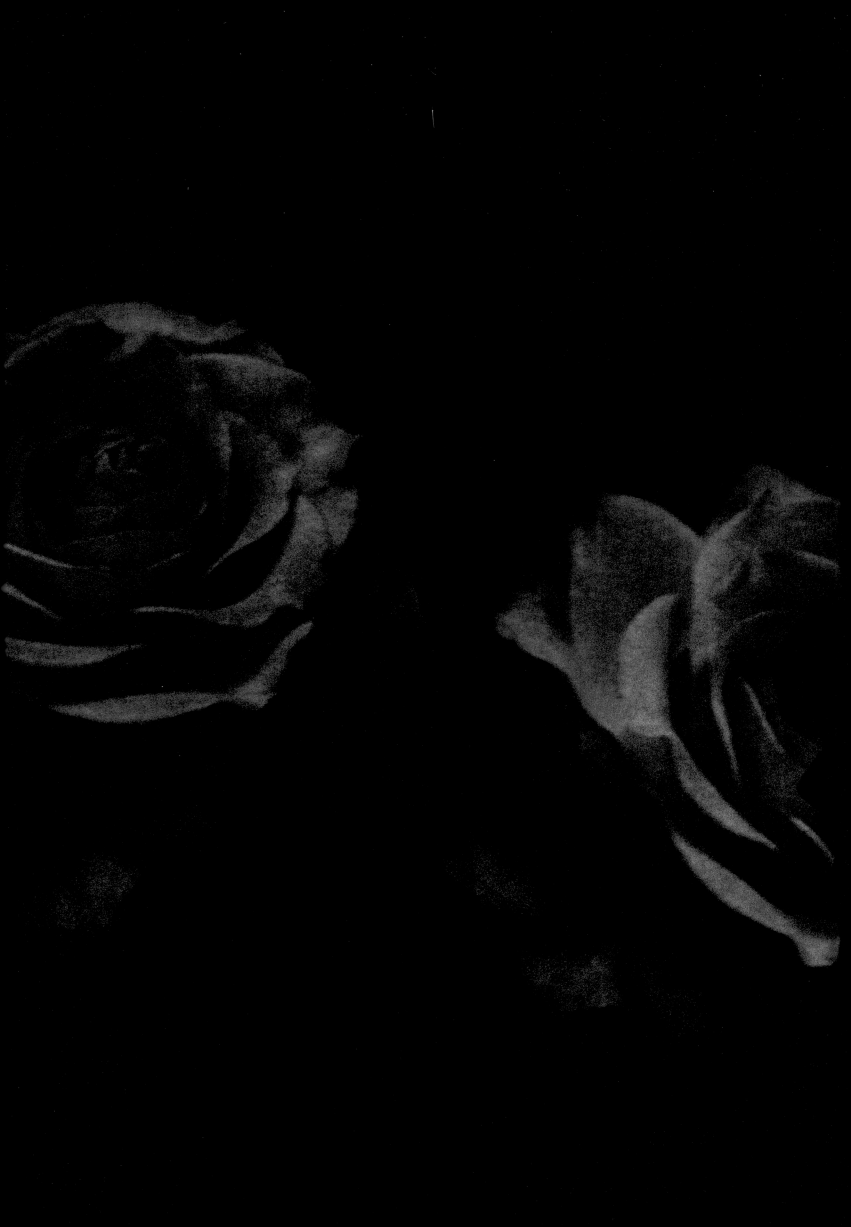

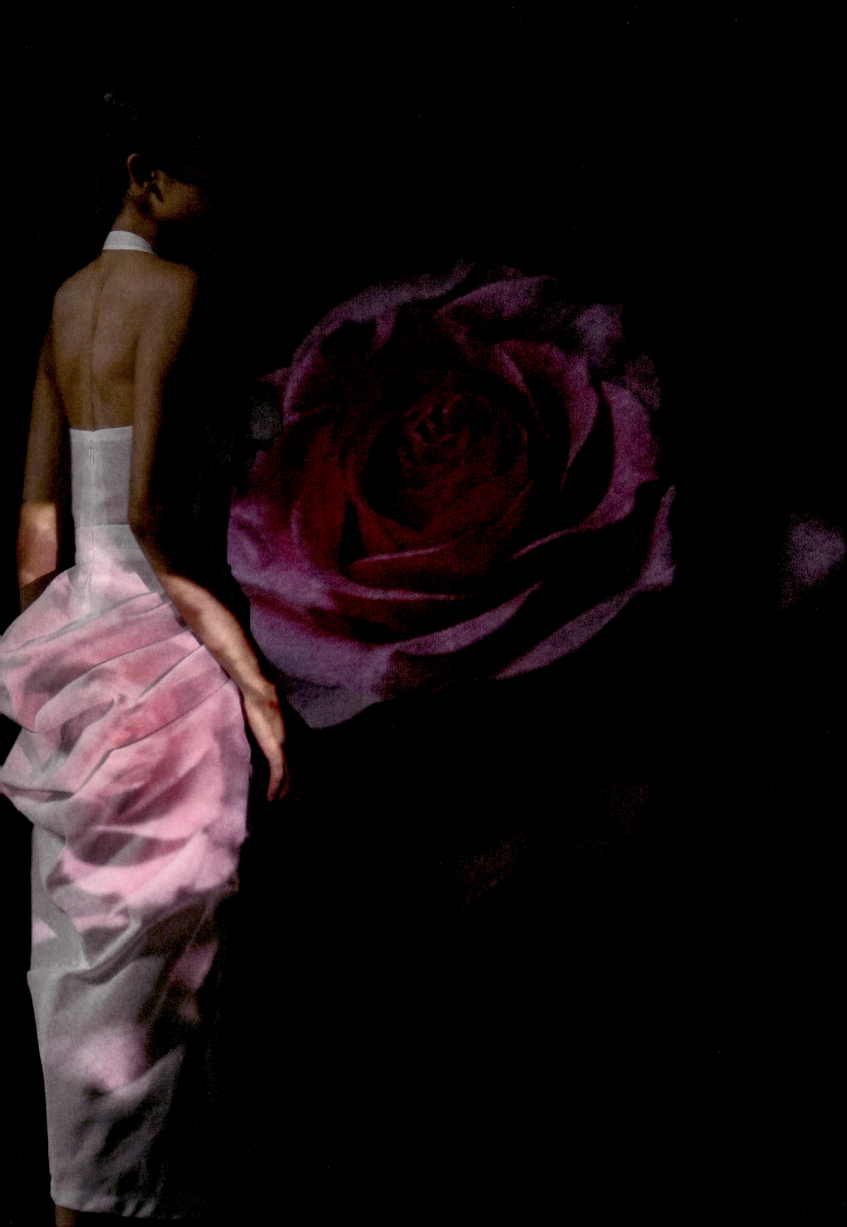

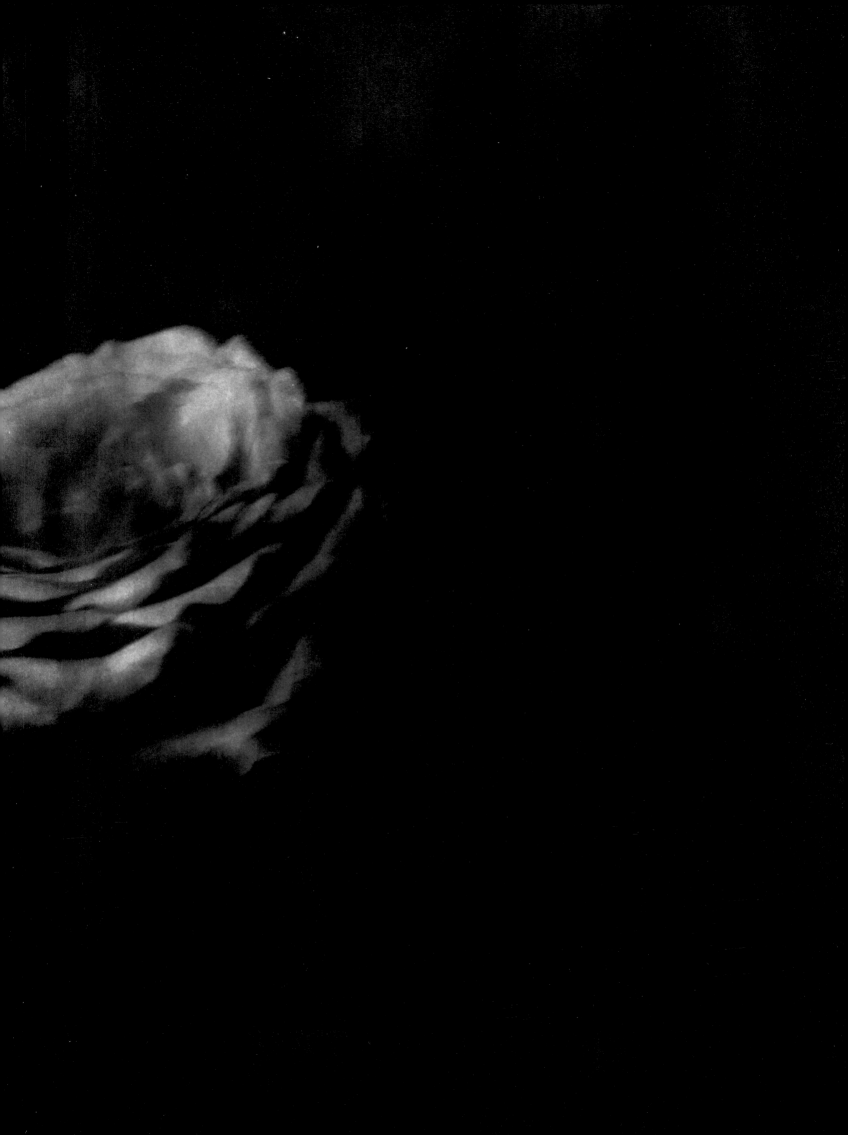

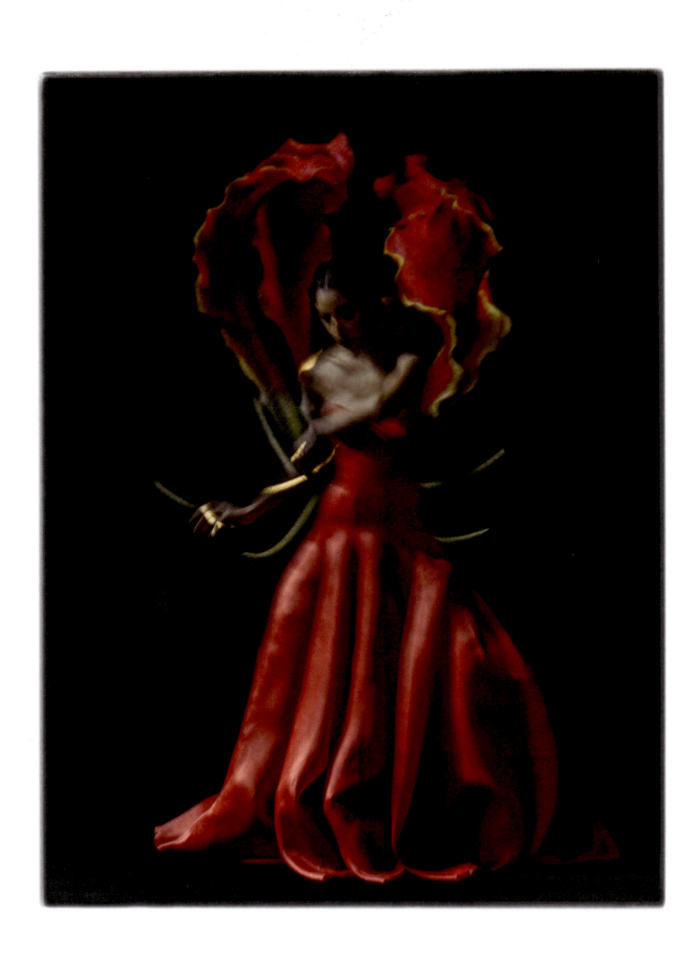

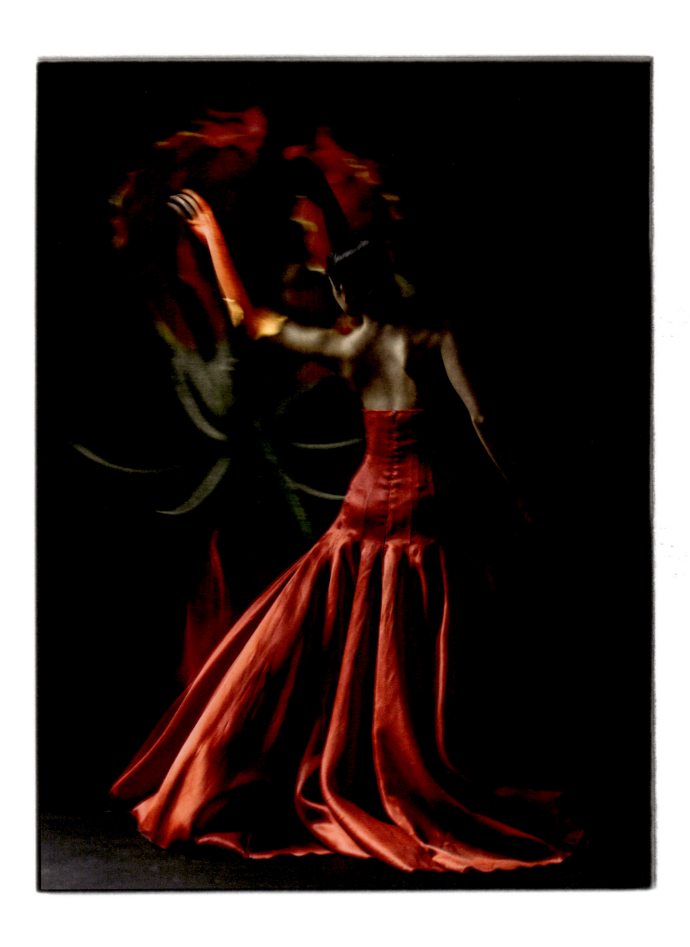

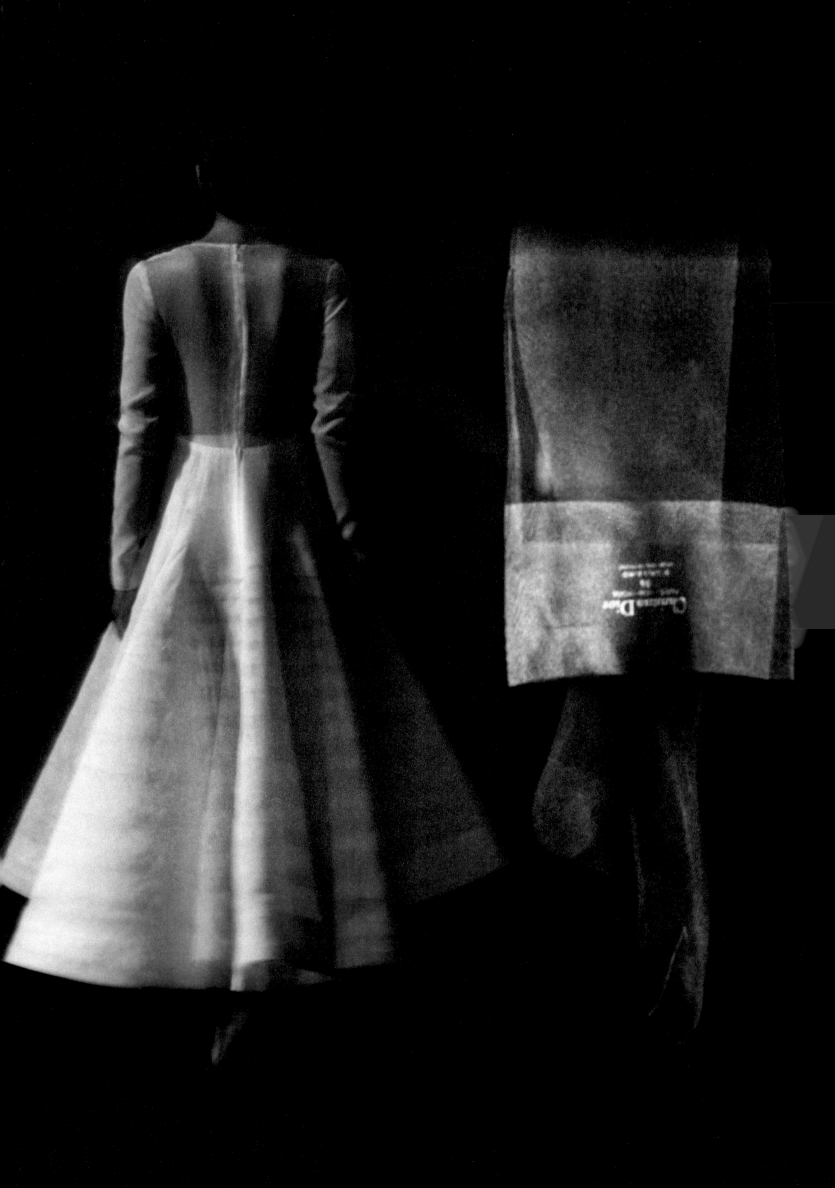

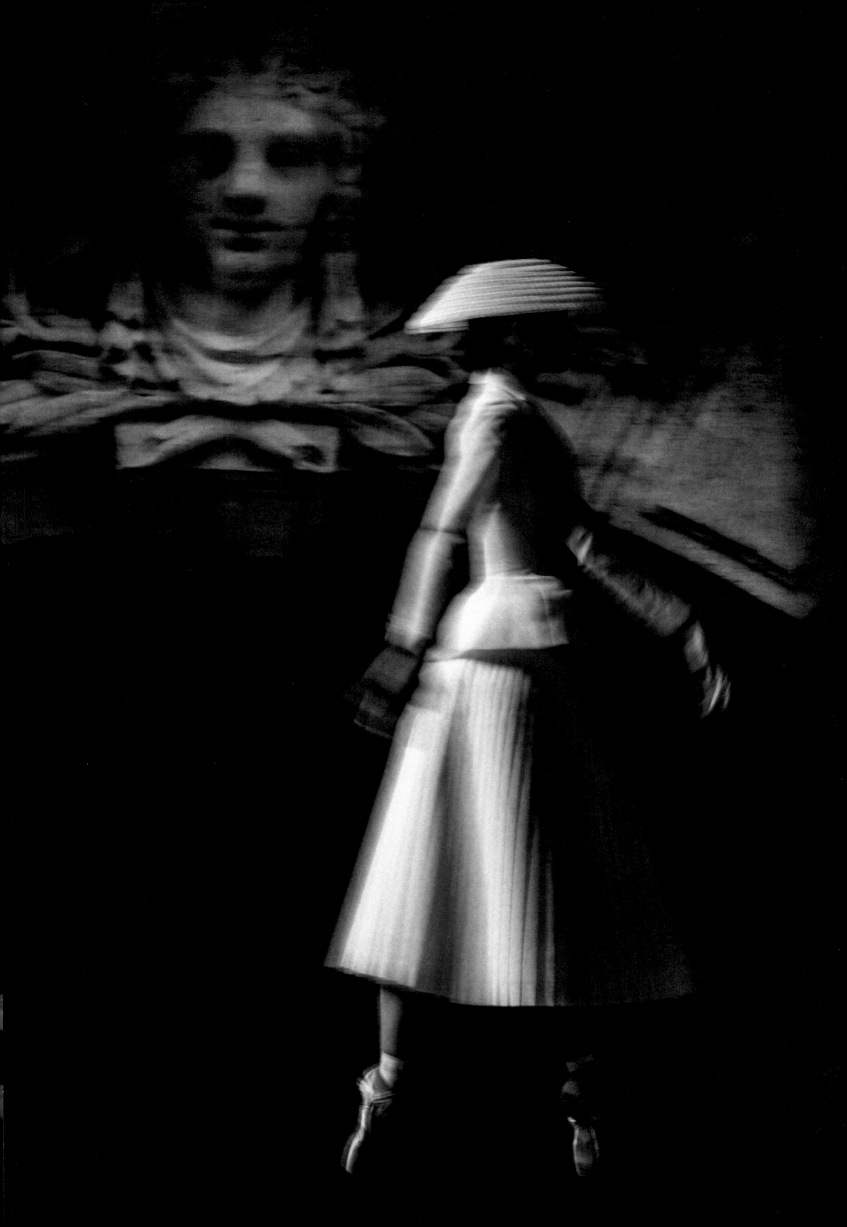

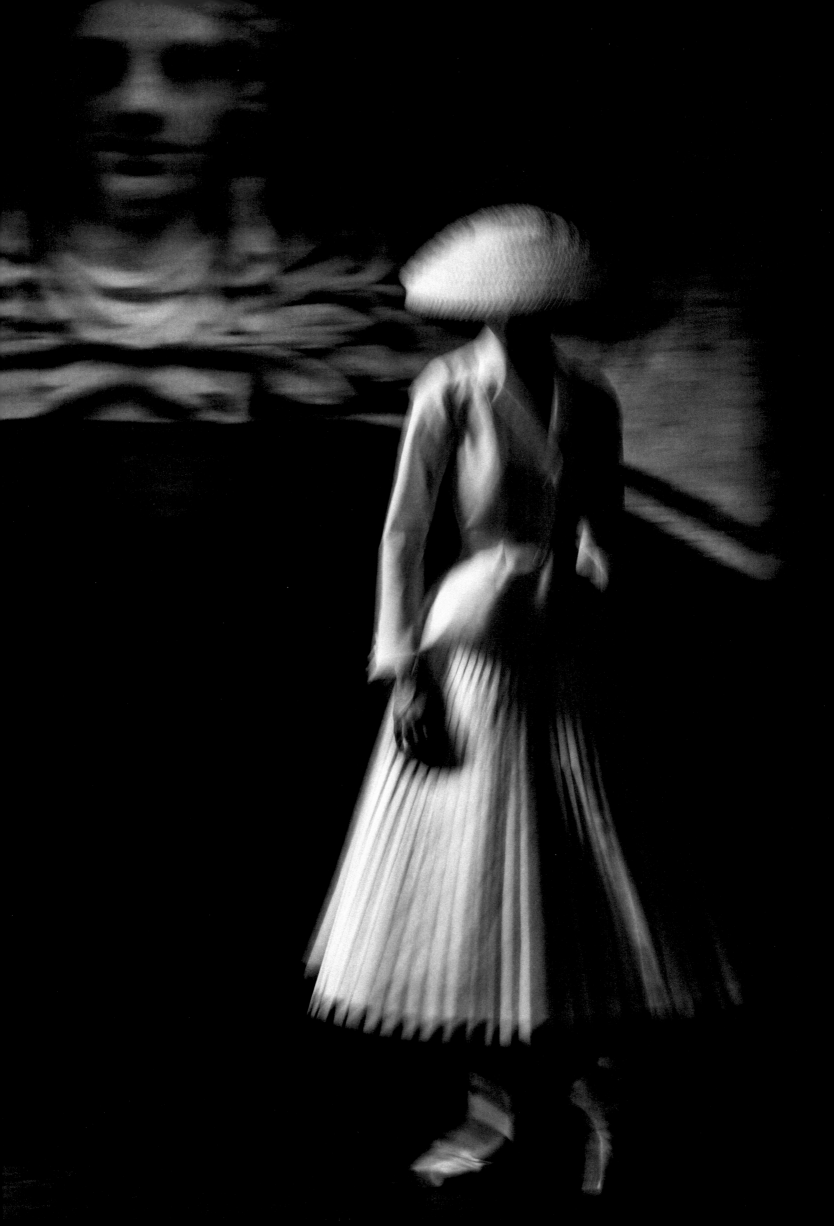

LIKE THE
SKETCHES THAT
INSPIRED THEM,
THE IMPORTANCE
OF THESE TOILES
IS ENTIRELY
IN THEIR SILHOUETTE,
CUT, AND LINE.

C.D.

LIKE THE
SKETCHES THAT
INSPIRED THEM,
THE IMPORTANCE
OF THESE TOILES
IS ENTIRELY
IN THEIR SILHOUETTE,
CUT, AND LINE.

C. D.

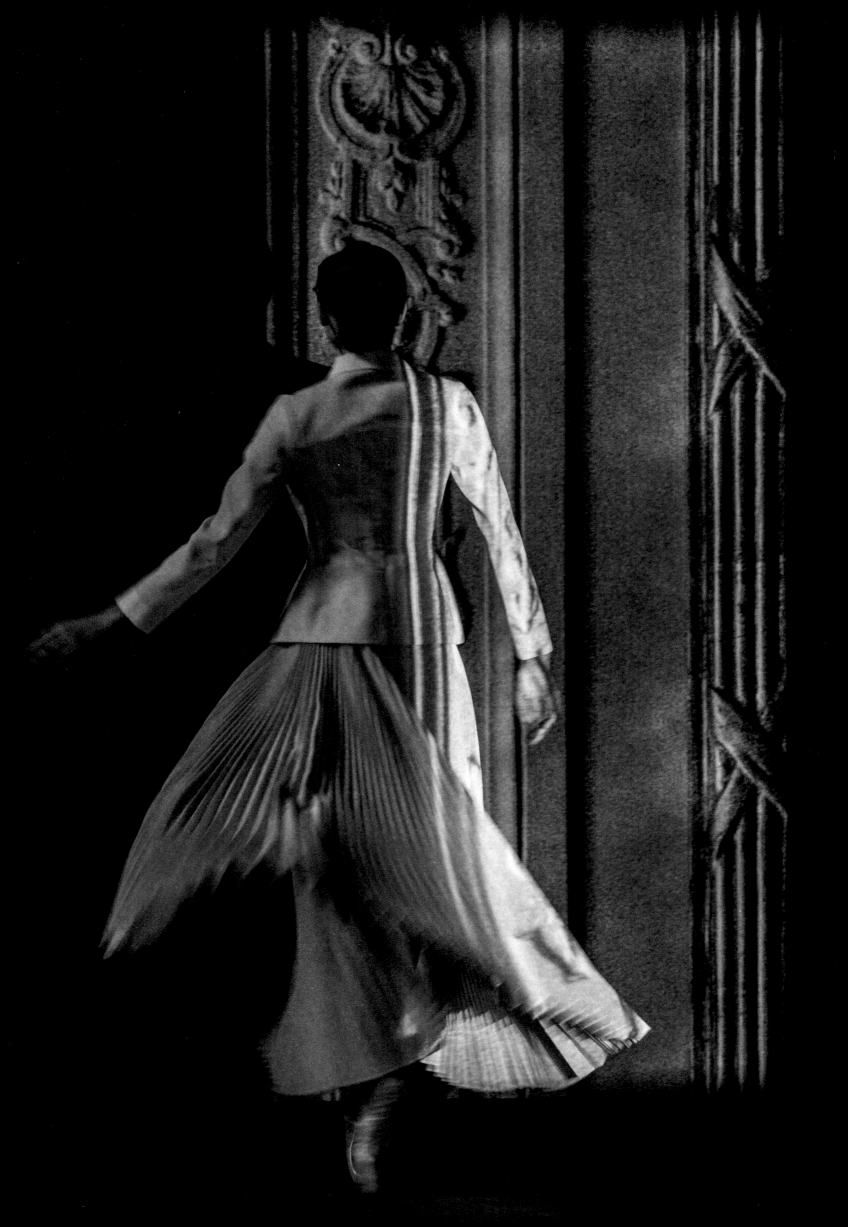

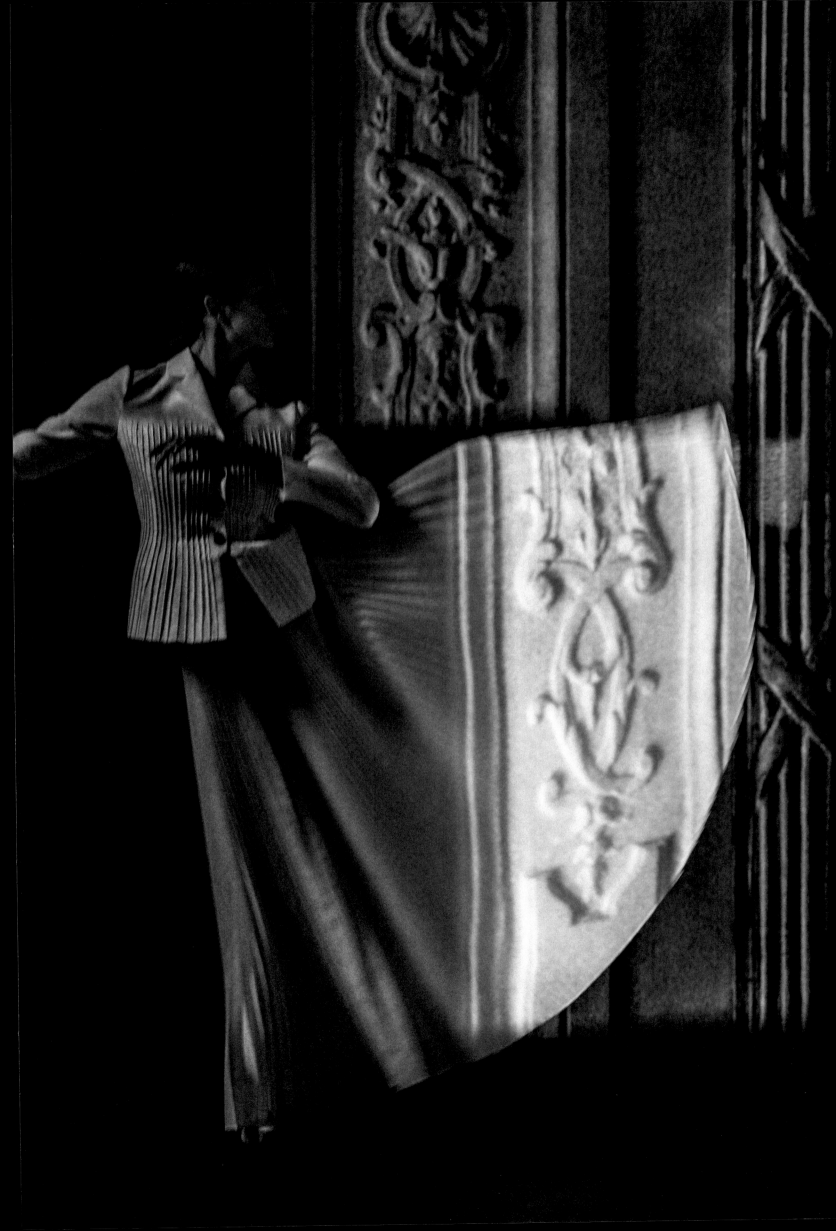

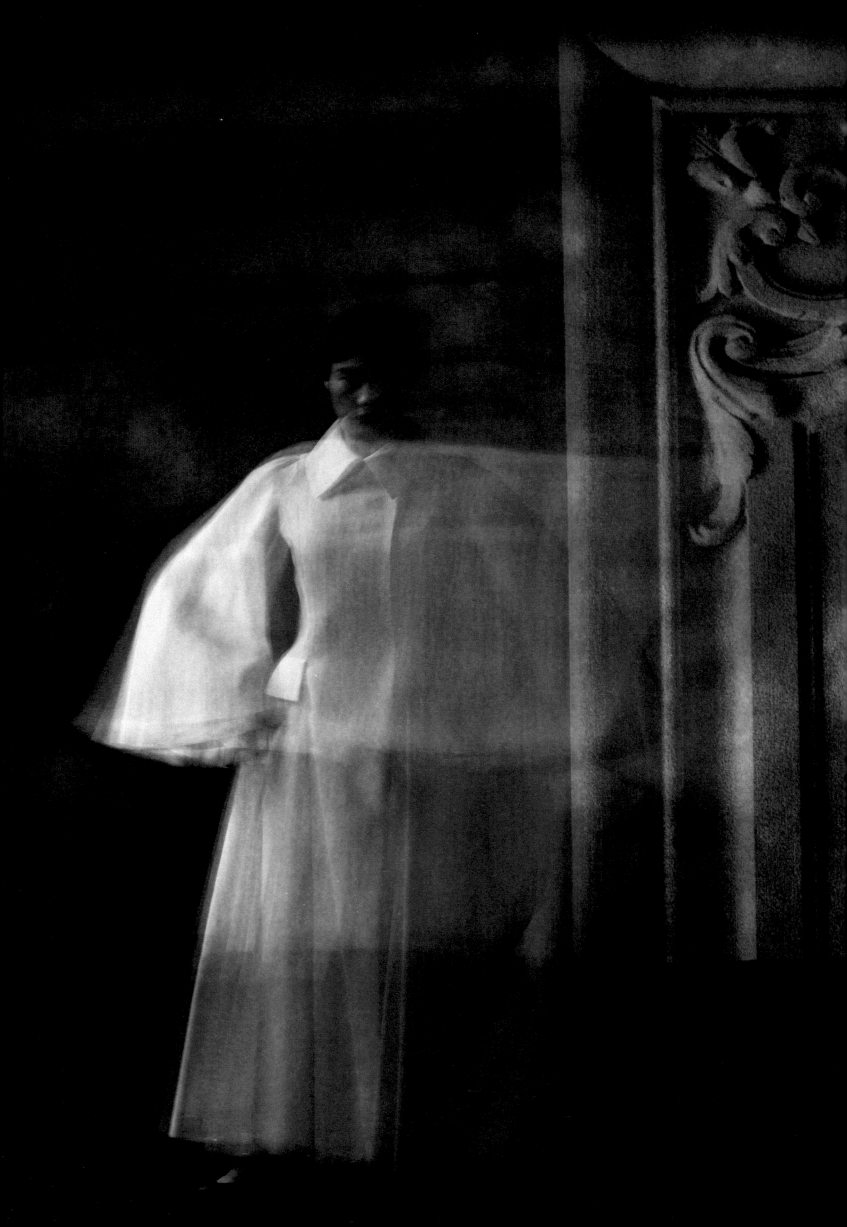

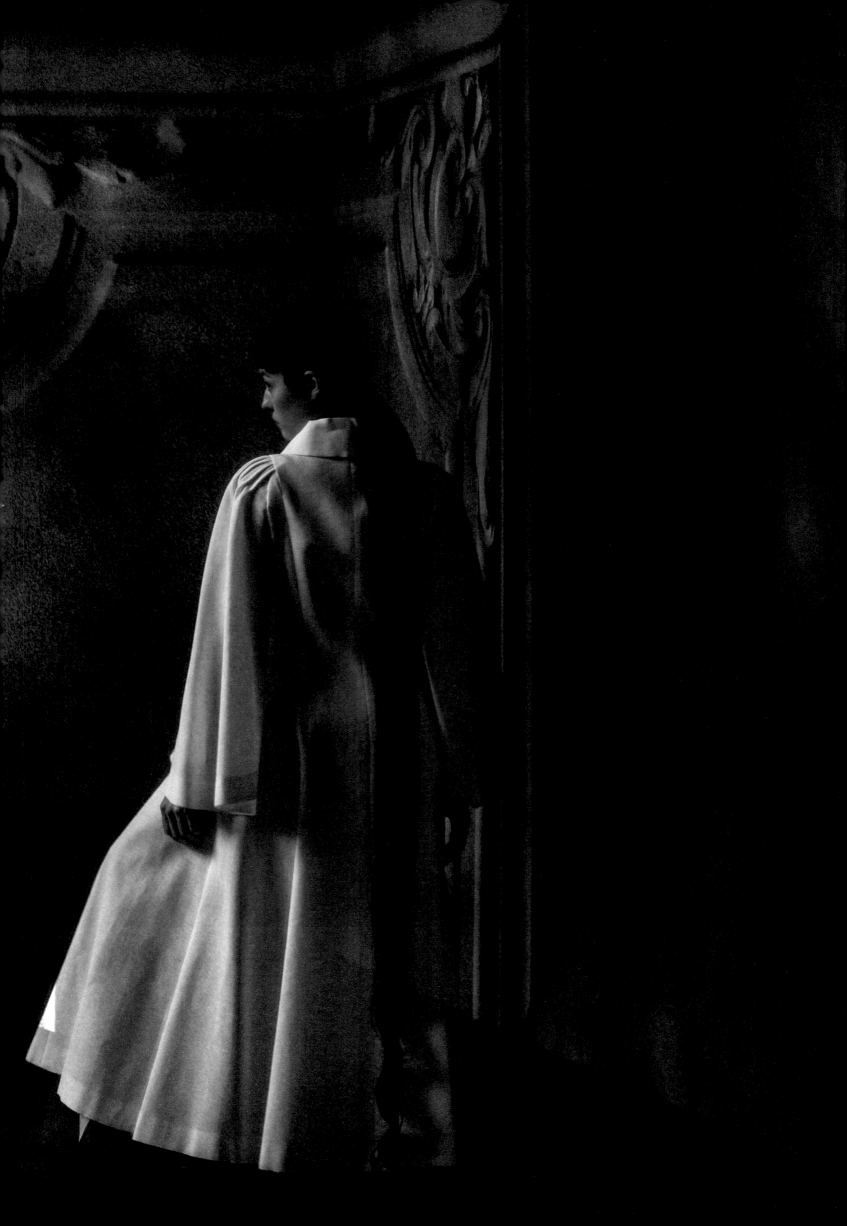

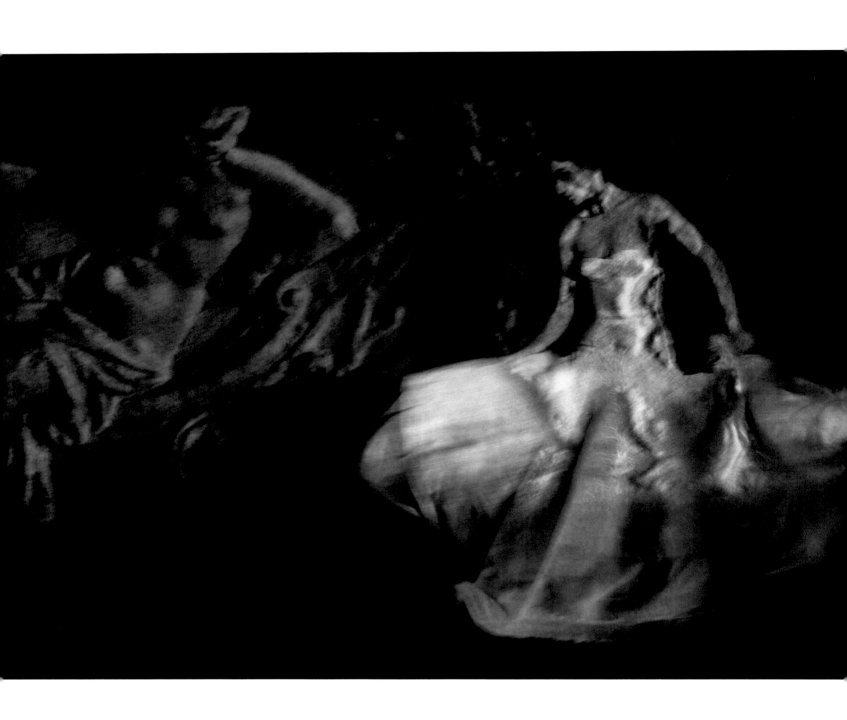

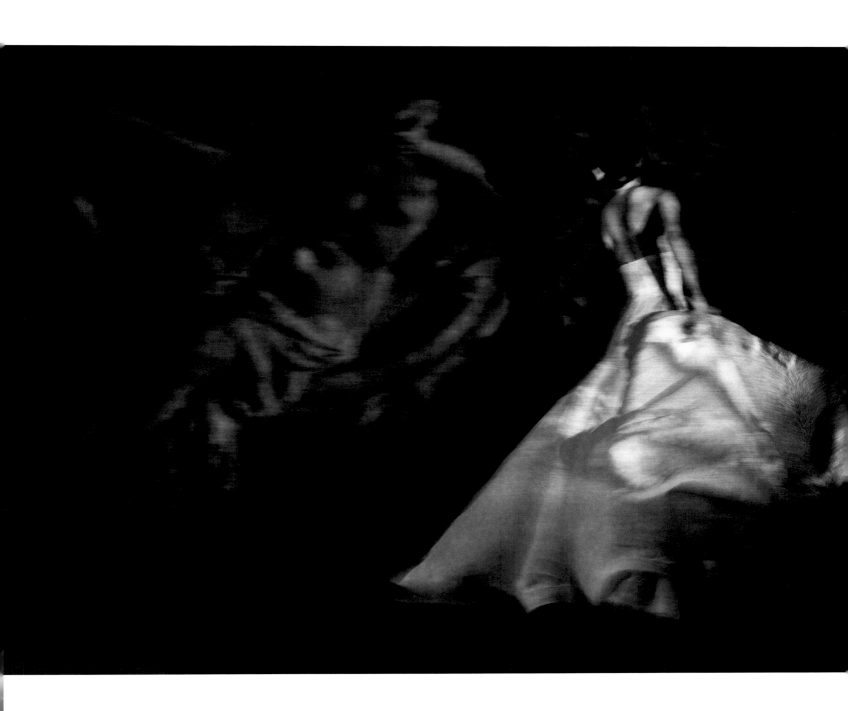

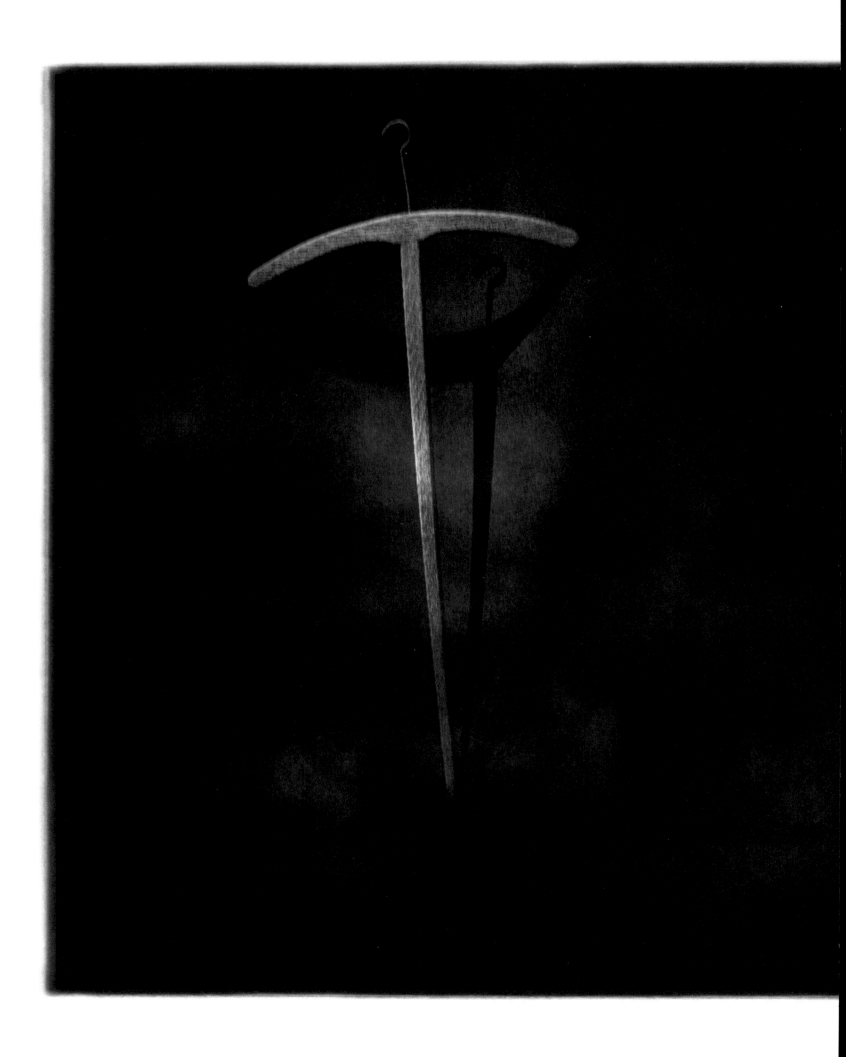

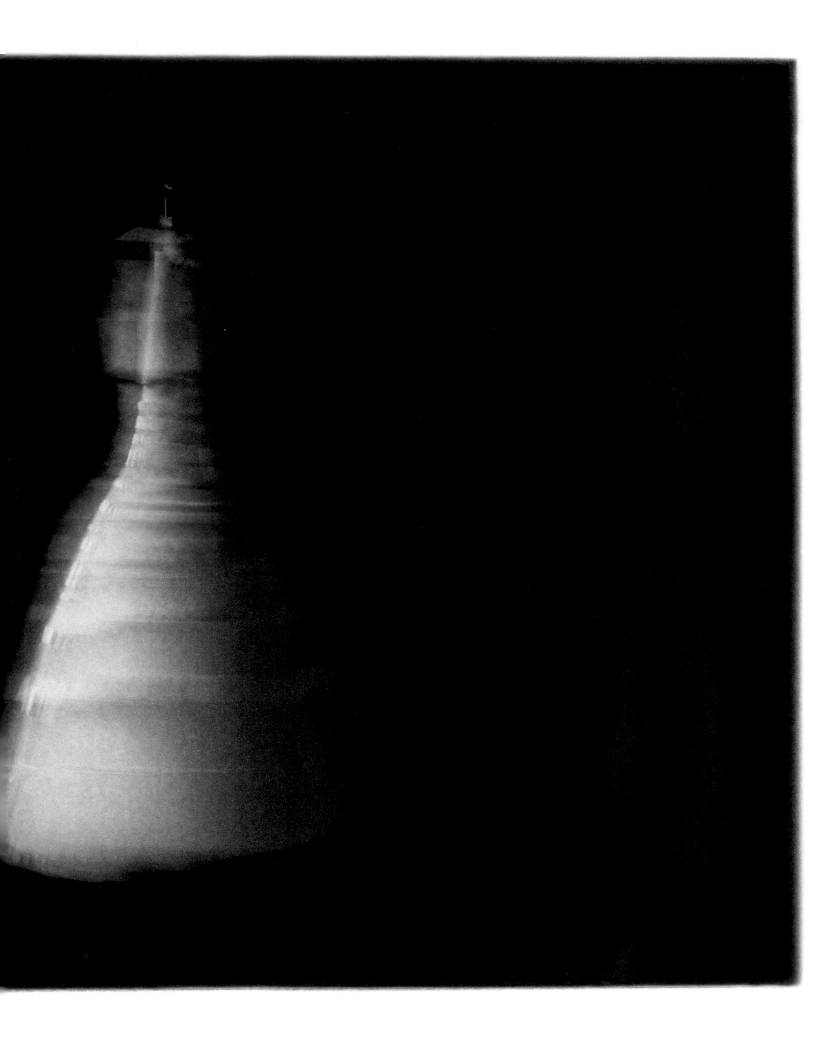

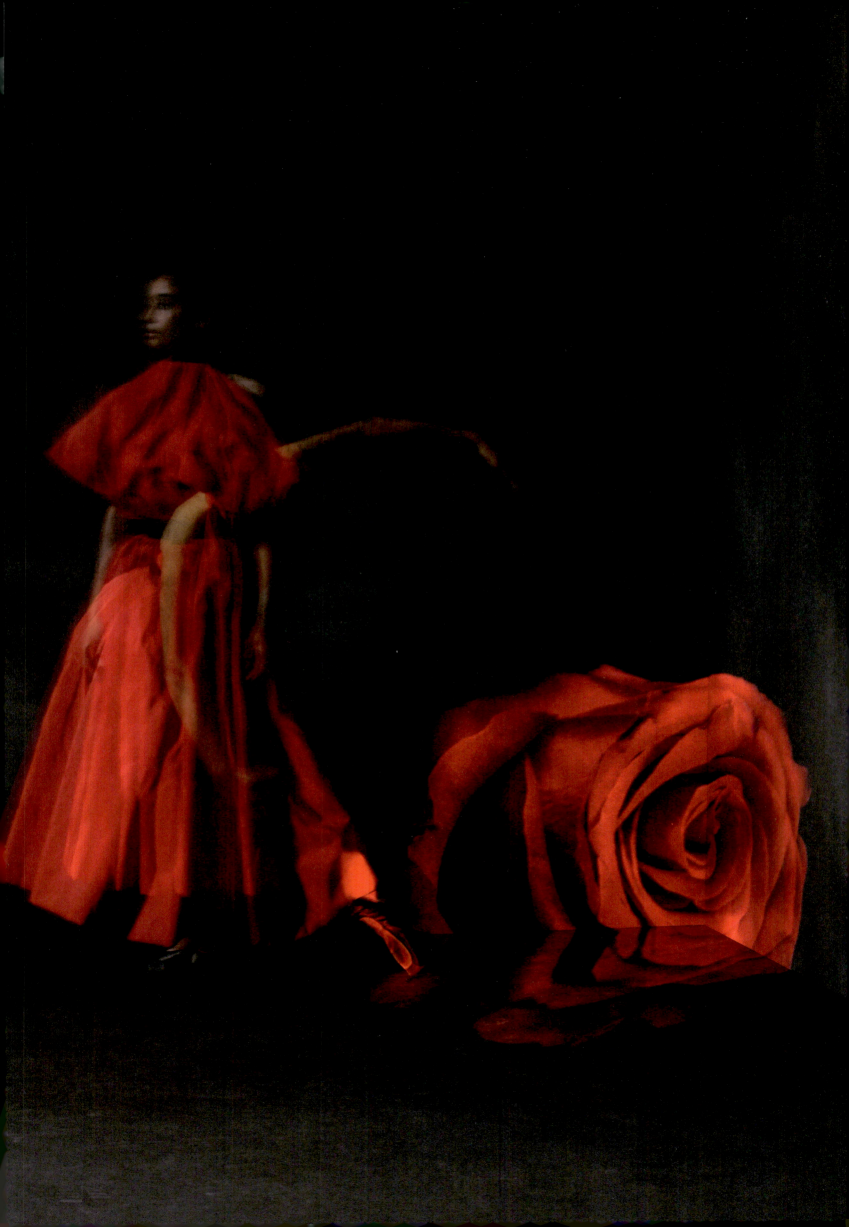

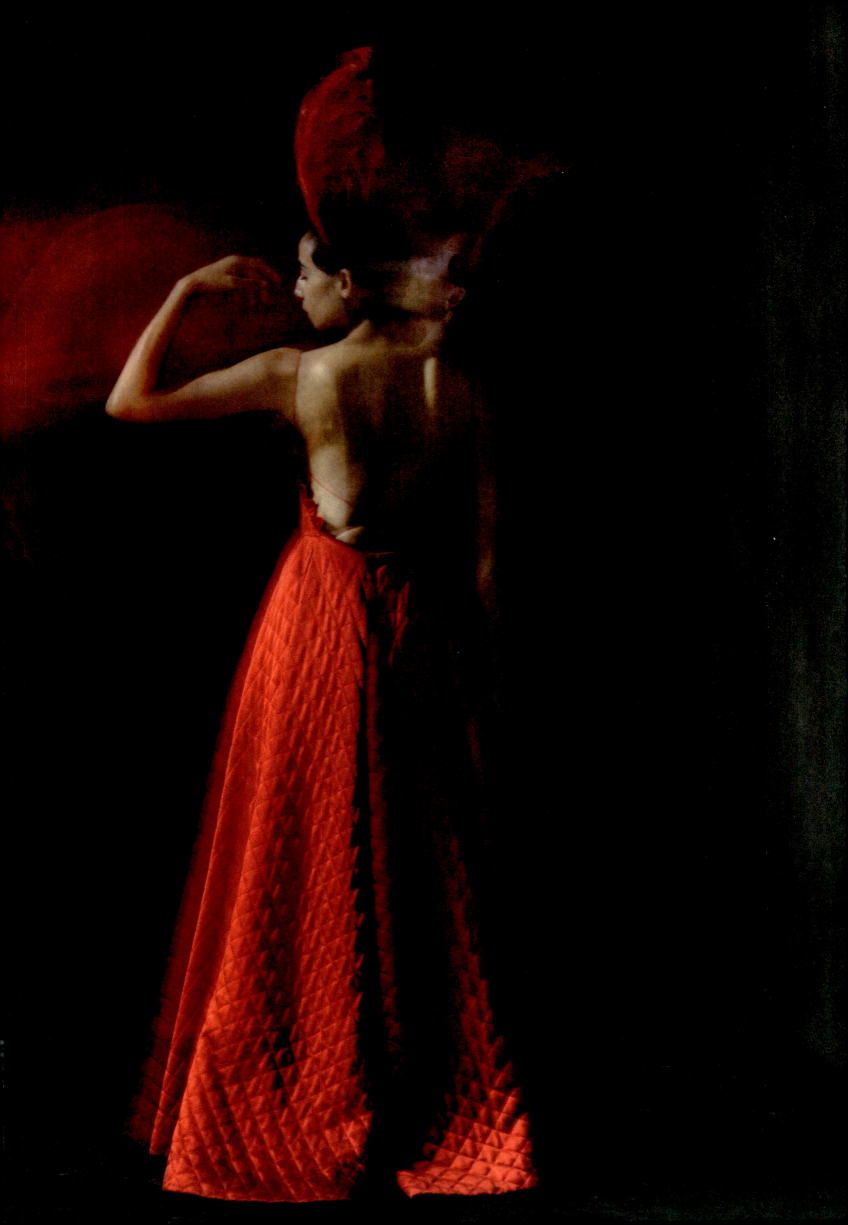

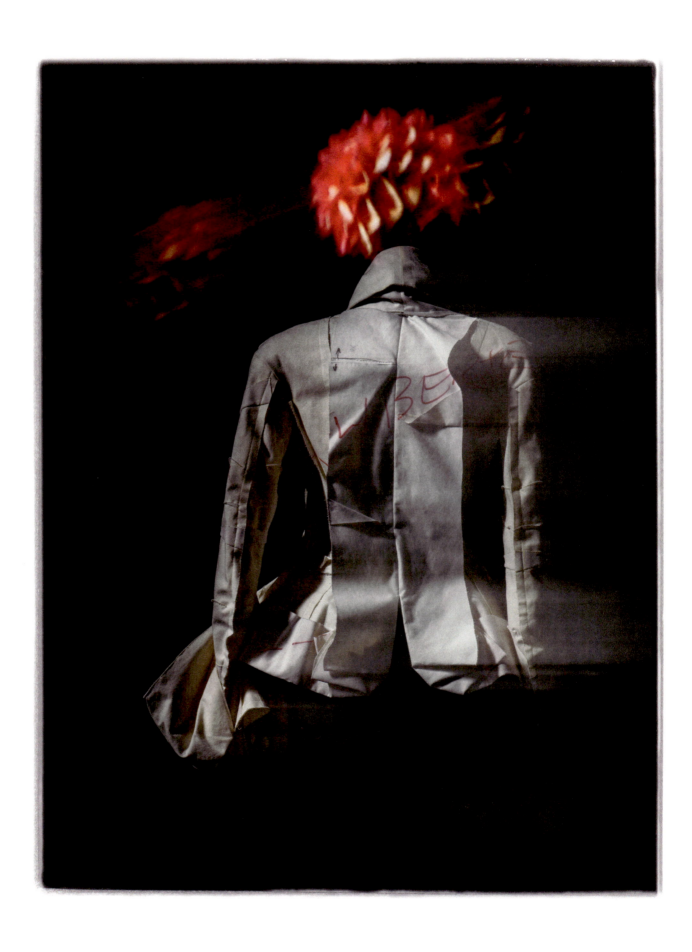

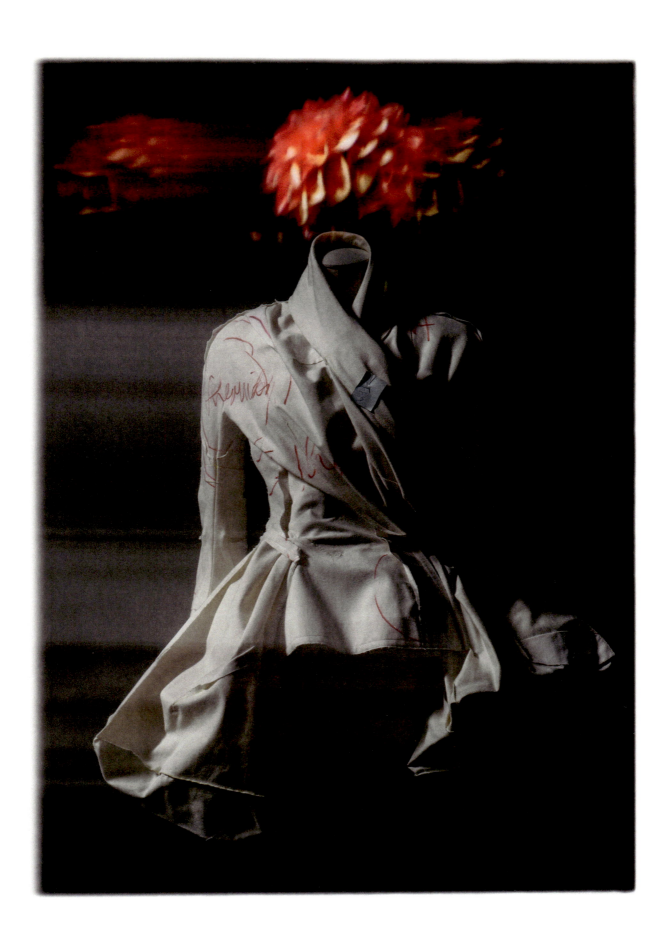

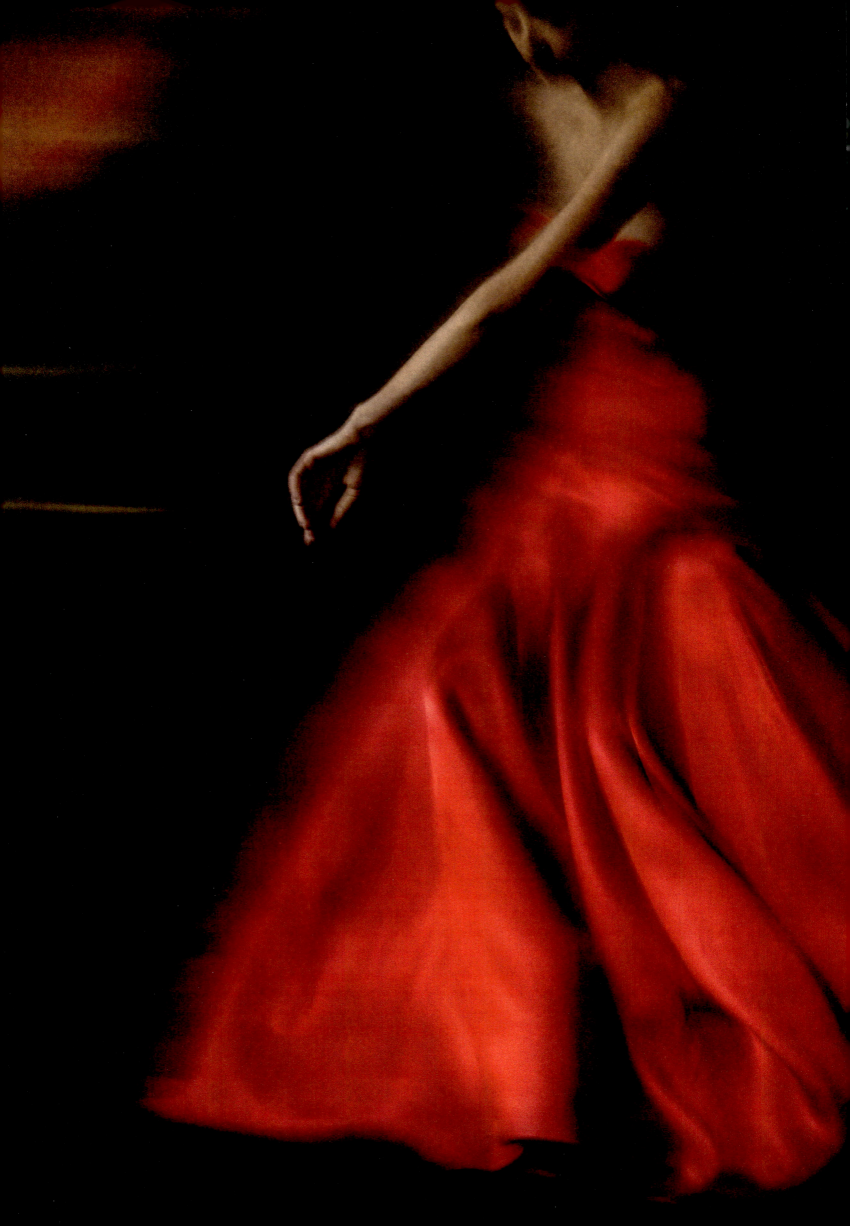

WHEREAS THE TOILES
LEAVE THE
IMAGINATION FREE
TO CONCEIVE
THE REST, DRESSES
ARE THE REALITY.

C.D.

WHEREAS THE TOILES
LEAVE THE
IMAGINATION FREE
TO CONCEIVE
THE REST, DRESSES
ARE THE REALITY.

C.D.

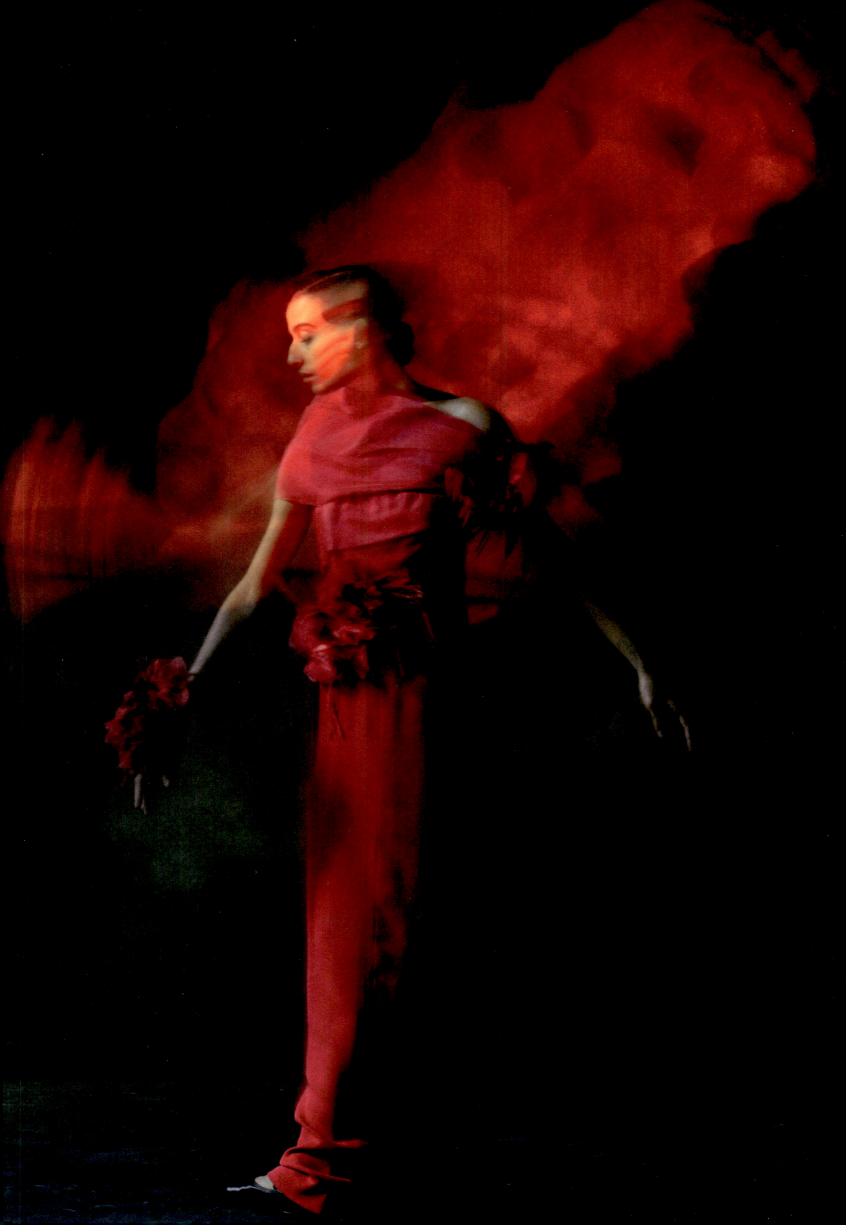

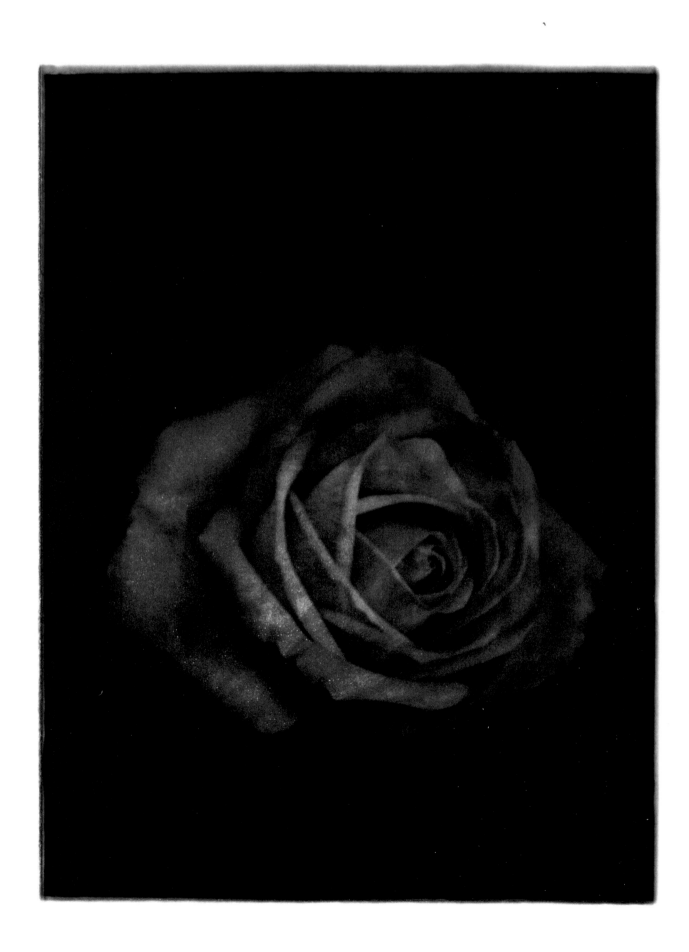

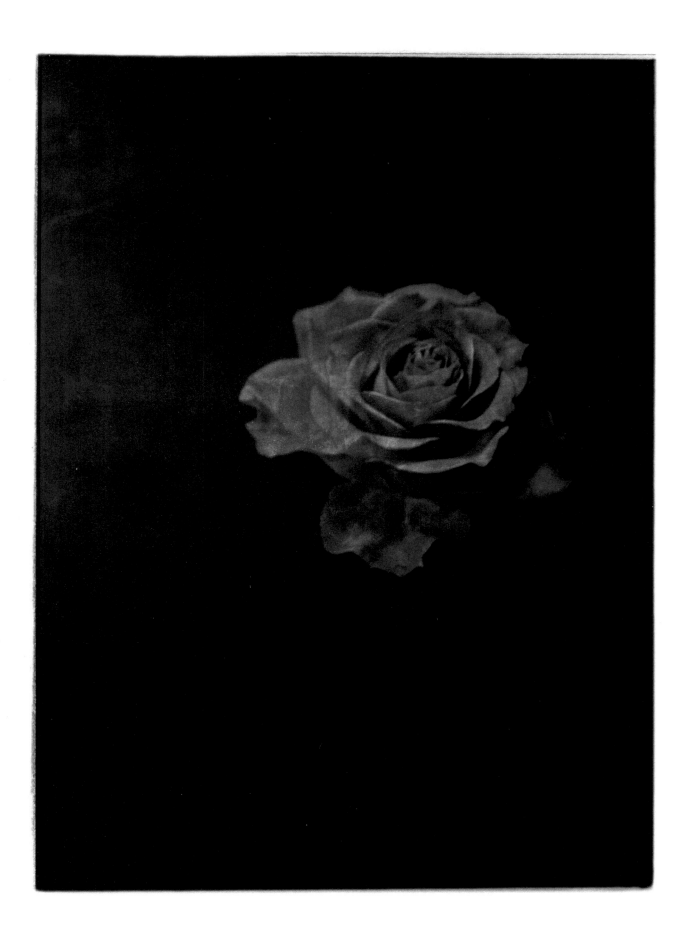

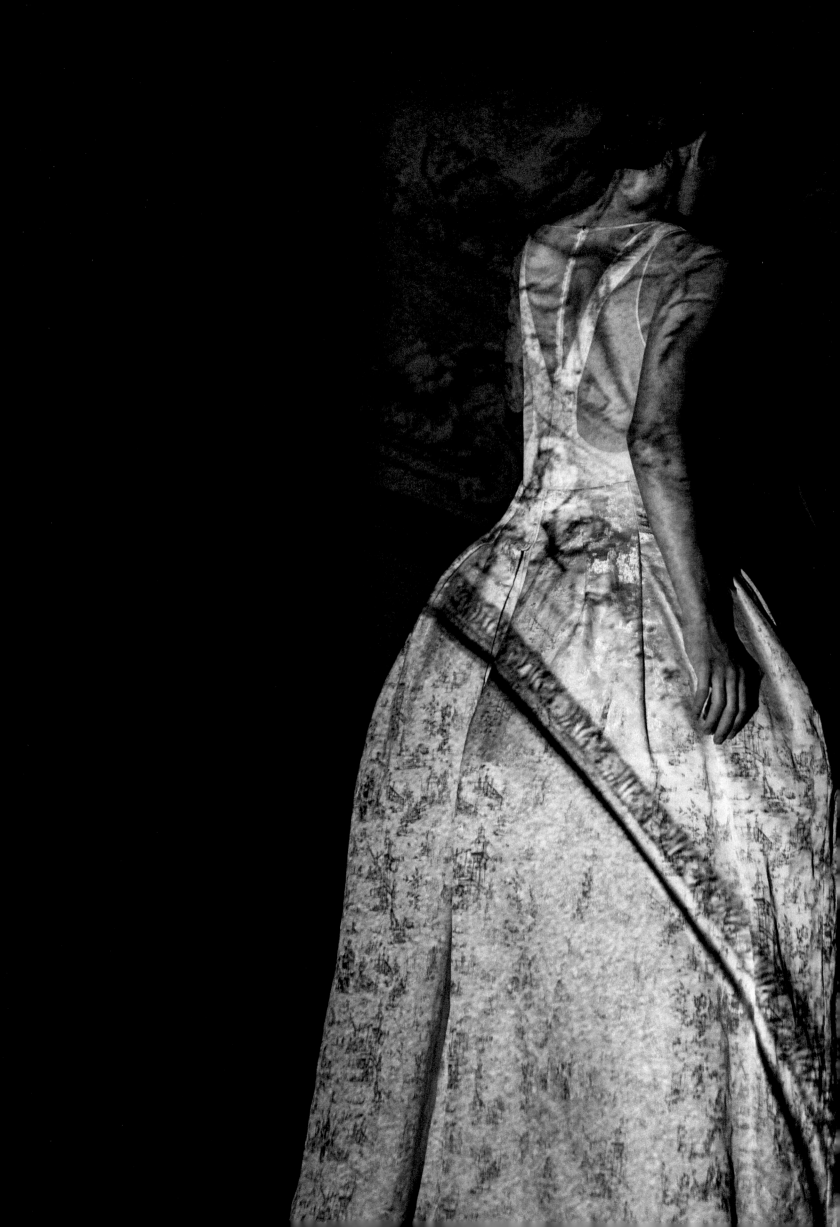

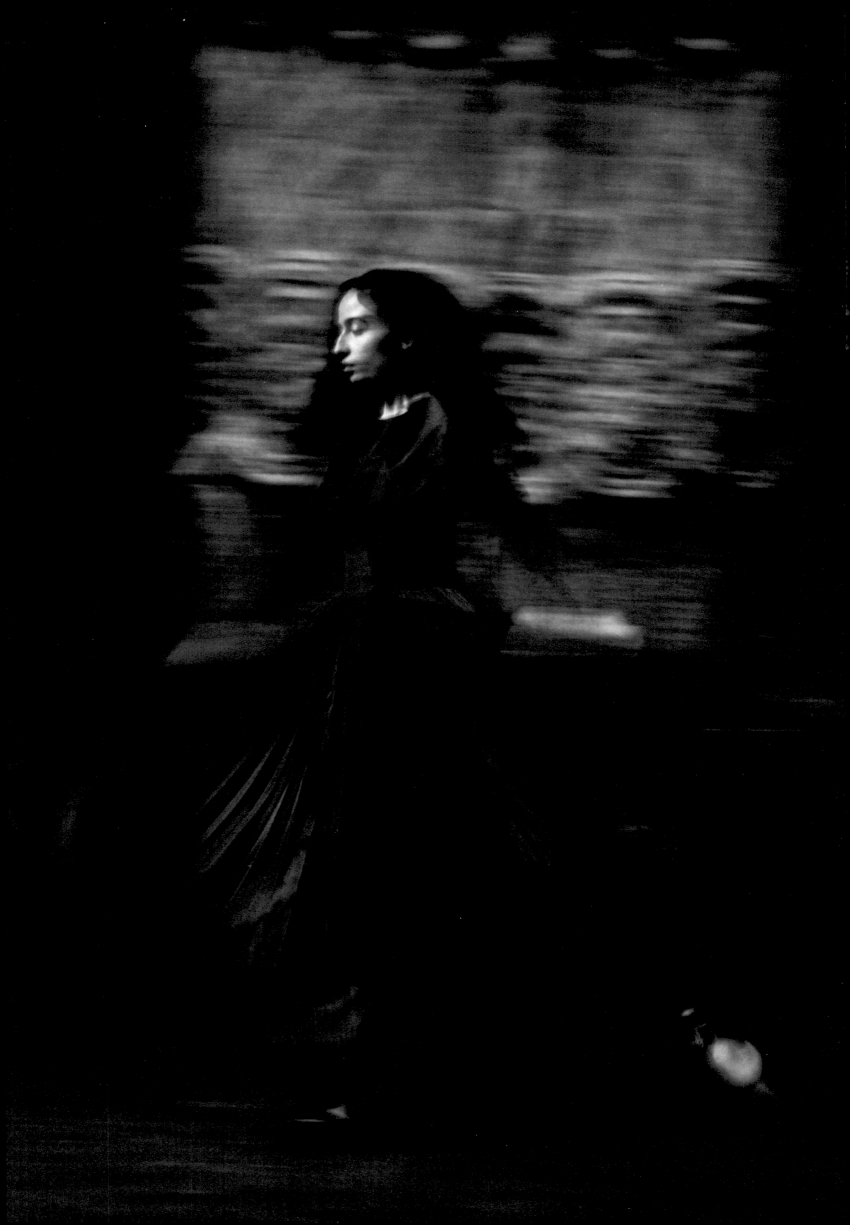

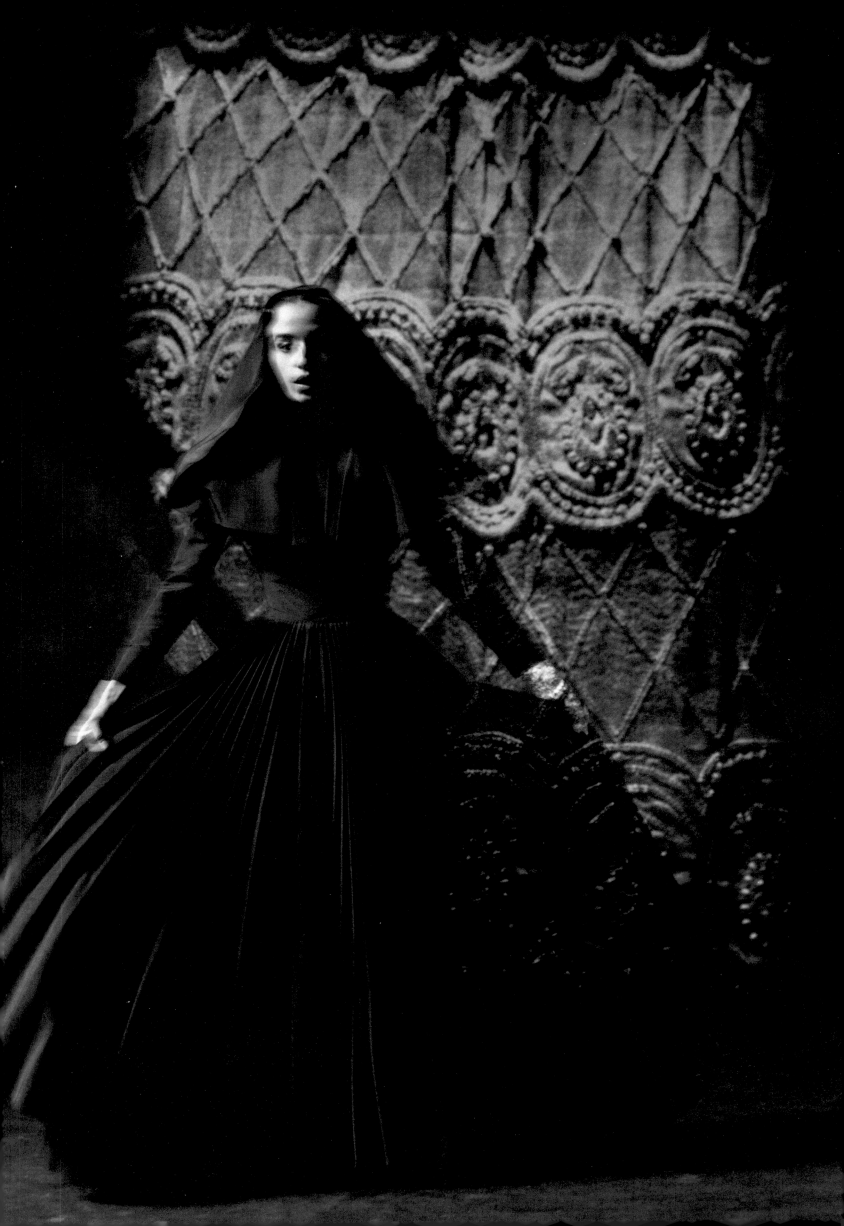

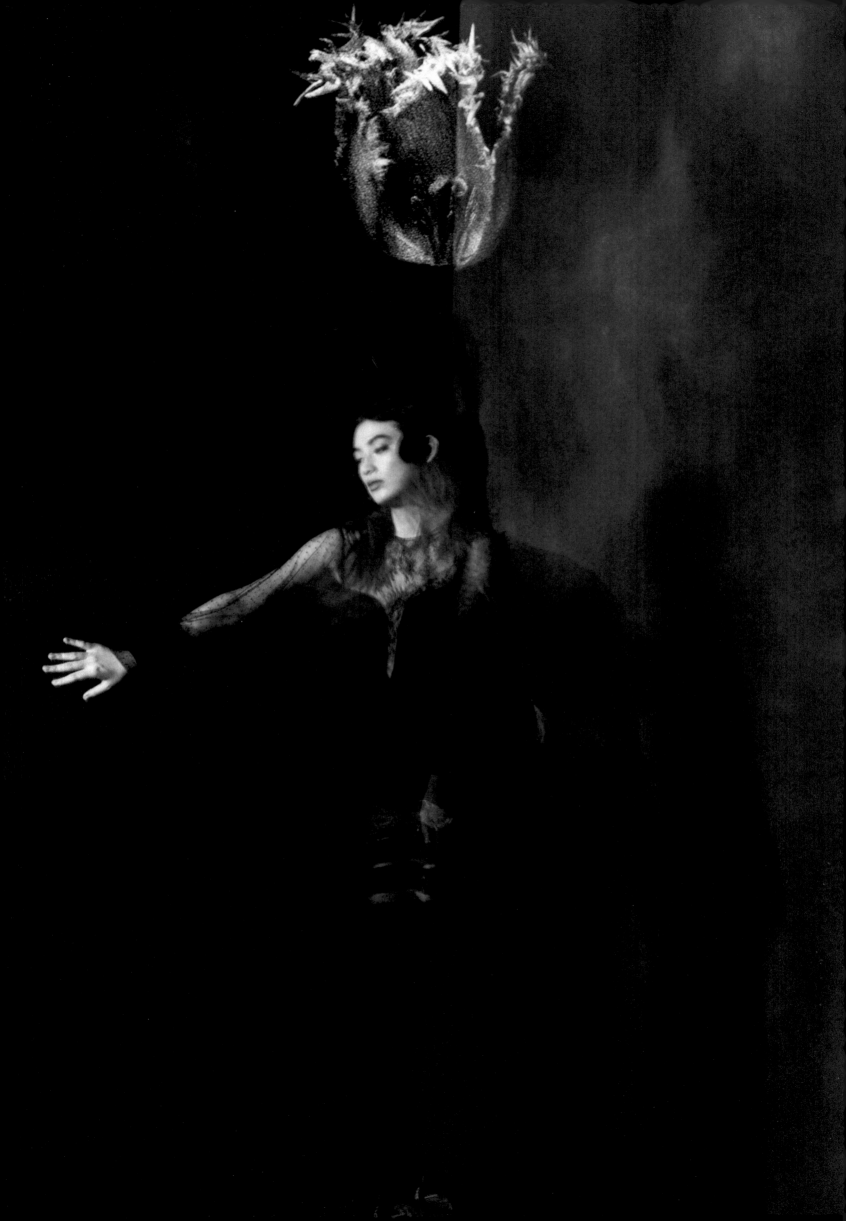

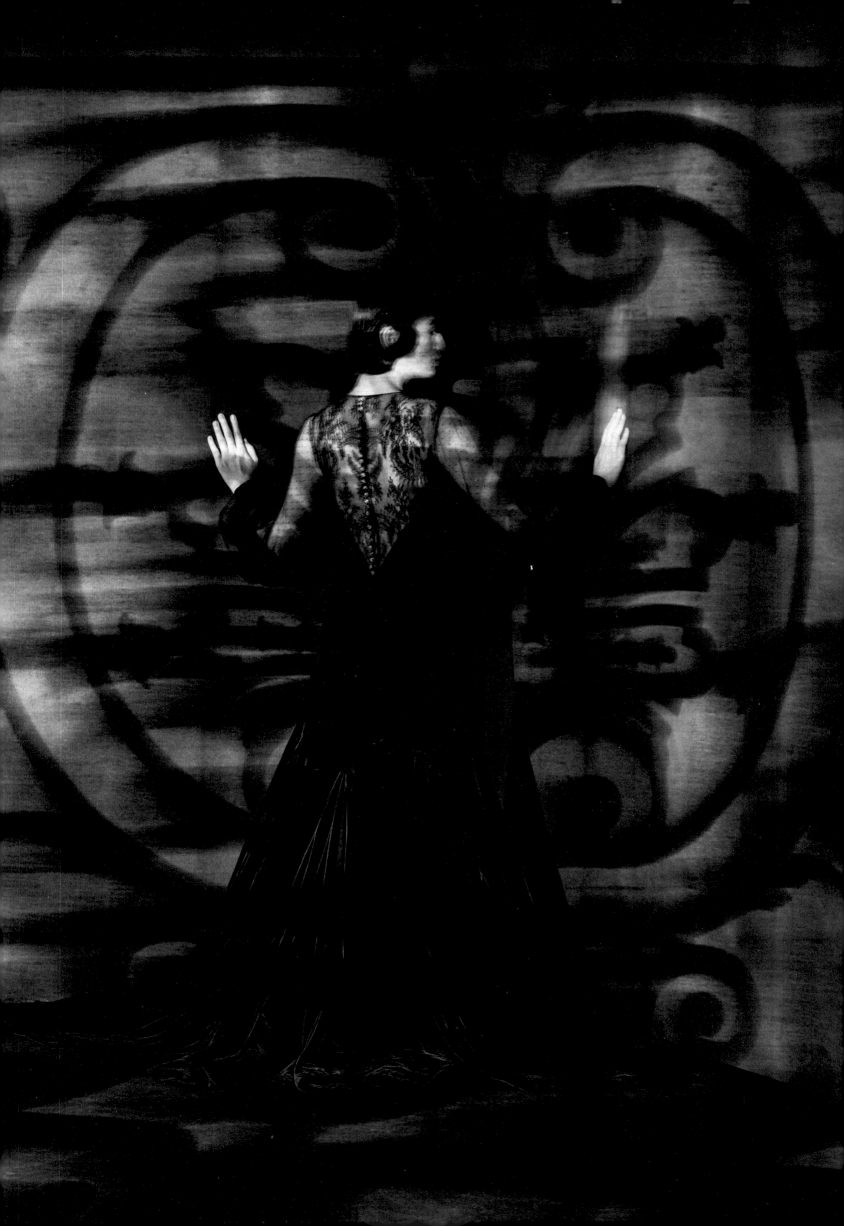

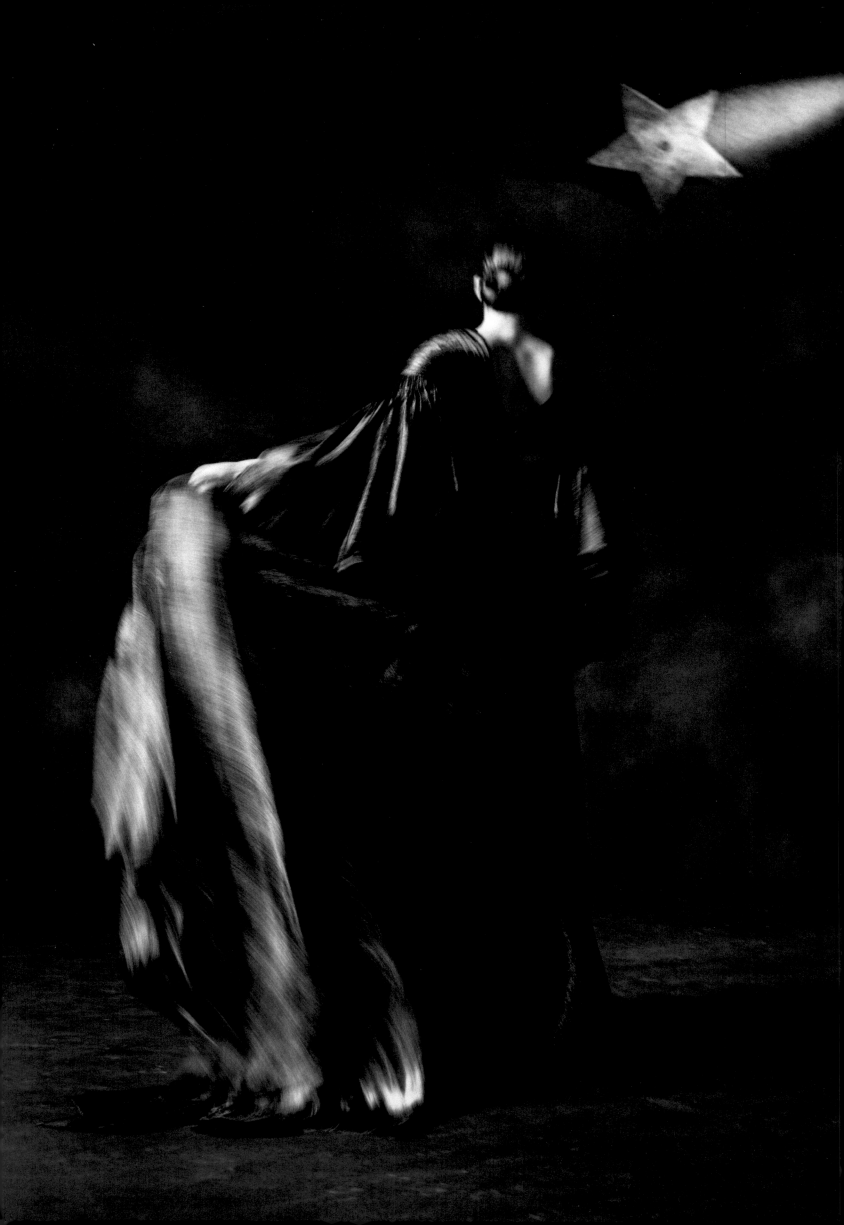

Captions

All the couture pieces, *toiles*, and accessories are from the collections of Dior Héritage.

The perfume bottles are from the collections of Parfums Christian Dior.

All projected images are by Yuriko Takagi. The interiors and architectural ornamentation—façade, grand staircase, collection presentation salons, models' *cabine*—are at the House of Dior's historic home, the *hôtel particulier* at 30 Avenue Montaigne, Paris.

15

Maria Grazia Chiuri for Christian Dior
Numéro 355 – L'étoile long draped gown
Spring–Summer 2021 haute couture collection

16–17

Maria Grazia Chiuri for Christian Dior
Numéro 355 – L'étoile long draped gown and its toile
Spring–Summer 2021 haute couture collection

19, 20

Raf Simons for Christian Dior
look 1 dress
Autumn–Winter 2014 haute couture collection

22, 23

Christian Dior
toile for *États-Unis* gala dress
Autumn–Winter 1951 haute couture collection,
Longue line

Stephen Jones for Christian Dior
hat for the *Yum-Yum-San* evening dress
by John Galliano for Christian Dior
Spring–Summer 2007 haute couture collection

27

Christian Dior
toile for *Songe* long evening gown
Spring–Summer 1947 haute couture collection,
Corolle line

28, 29

Gianfranco Ferré for Christian Dior
toile for *Silence* dress
Autumn–Winter 1989 haute couture collection,
Ascot–Cecil Beaton

31
Christian Dior
toile for *Soirée de décembre* evening gown
Autumn–Winter 1955 haute couture collection,
Y line

Mitchel Maer for Christian Dior
brooch in the form of a flower
Autumn–Winter 1951

32
John Galliano for Christian Dior
toile for look 36 dress
Autumn–Winter 2008 haute couture collection

Mitchel Maer for Christian Dior
brooch in the form of a chrysanthemum, 1955–58

35
Maria Grazia Chiuri for Christian Dior
toile for *Numéro 4* dress
Autumn–Winter 2018 haute couture collection

36–37
Christian Dior
toile for *Jean Cocteau* evening gown
Spring–Summer 1952 haute couture collection,
Sinueuse line

38–39
Maria Grazia Chiuri for Christian Dior
toile for *Numéro 71* bustier dress
Autumn–Winter 2018 haute couture collection

42–43
Maria Grazia Chiuri for Christian Dior
Numéro 71 bustier dress
Autumn–Winter 2018 haute couture collection

45
Christian Dior
toile for *Colette* dinner-party dress
Spring–Summer 1947 haute couture collection,
Corolle line

Miss Dior amphora perfume bottle, 1947

46–47
Marc Bohan for Christian Dior
look 103 dress and its toile
Spring–Summer 1986 haute couture collection

48
Raf Simons for Christian Dior
toile for look 7 bustier cocktail dress
Spring–Summer 2013 haute couture collection

Diorling special edition perfume bottle, 1963

49
Christian Dior
toile for *Soirée d'Asie* evening gown
Autumn–Winter 1955 haute couture collection,
Y line

L'or de J'adore perfume bottle, 2023

50
John Galliano for Christian Dior
toile for look 1 evening dress
Autumn–Winter 2006 haute couture collection

53
John Galliano for Christian Dior
toile for look 23 dress
Spring–Summer 2010 haute couture collection

54, 55
Christian Dior
toile for *Soirée de Londres* evening dress
Autumn–Winter 1955 haute couture collection,
Y line

56–57
Maria Grazia Chiuri for Christian Dior
toile for *Numéro 11* cocktail dress
Autumn–Winter 2018 haute couture collection

60–61
Christian Dior
toile for *The Village* day dress
Christian Dior-New York Spring–Summer 1954
collection, *The Balanced Look*

62, 63
John Galliano for Christian Dior
toile for look 10 jacket
Spring–Summer 2009 haute couture collection

64–65
Maria Grazia Chiuri for Christian Dior
Alchimiste checkerboard ensemble consisting
of a bustier dress and a short cape
Spring–Summer 2018 haute couture collection

Roger Vivier for Christian Dior
pump, ca. 1959

66–67

Gianfranco Ferré for Christian Dior
Disney suit and its toile
Autumn–Winter 1989 haute couture collection,
Ascot–Cecil Beaton

68

Raf Simons for Christian Dior
look 19 evening dress
Autumn–Winter 2012 haute couture collection

Christian Dior
original sketch for a dress
Autumn–Winter 1950 haute couture collection,
Oblique line

73

Stephen Jones for Christian Dior
L'oiseau headpiece for the *Bar* suit *Voyage de l'âme* by Maria Grazia Chiuri for Christian Dior
Spring–Summer 2017 haute couture collection

74–75

Raf Simons for Christian Dior
toile for look 10 *Bar* coat
Autumn–Winter 2012 haute couture collection

Christian Dior
original sketch for a dress
Autumn–Winter 1950 haute couture collection,
Oblique line

76, 77

Maria Grazia Chiuri for Christian Dior
Bar suit *Voyage de l'âme*
Spring–Summer 2017 haute couture collection

Christian Dior
original sketch for *Bernique* day dress
Autumn–Winter 1950 haute couture collection,
Oblique line

79

Christian Dior
Christian Bérard formal two-piece
Autumn–Winter 1949 haute couture collection,
Milieu du siècle line

Christian Dior
"cloche" hat
Christian Dior-New York collection, ca. 1953

80–81

Roger Vivier for Christian Dior
pump, 1962

Christian Dior
bonnet, ca. 1954

82, 83

John Galliano for Christian Dior
toile for *Konnichi-Kate* suit
Spring–Summer 2007 haute couture collection

85

Maria Grazia Chiuri for Christian Dior
Mémoire d'hiver (detail) ball gown
Spring–Summer 2017 haute couture collection

86, 89

Yves Saint Laurent for Christian Dior
Rose rouge dress
Spring–Summer 1959 haute couture collection,
Longue line

Marc Bohan for Christian Dior
"bibi" hat, ca. 1963

90, 91

John Galliano for Christian Dior
look 5 coat dress and its toile
Spring–Summer 2011 haute couture collection

92, 93

John Galliano for Christian Dior
look 7 dress
Spring–Summer 2010 haute couture collection

95

Marc Bohan for Christian Dior
cocktail dress
Autumn–Winter 1972 haute couture collection

96, 99

Christian Dior
Braque semi-evening dress
Autumn–Winter 1949 haute couture collection,
Milieu du siècle line

Maria Grazia Chiuri for Christian Dior
Mémoire d'hiver (detail) ball gown
Spring–Summer 2017 haute couture collection

102

Christian Dior
toile for *Braque* semi-evening dress
Autumn–Winter 1949 haute couture collection,
Milieu du siècle line

104–105

Christian Dior
toile for *Amour* restaurant dress
Spring–Summer 1947 haute couture collection,
En 8 line

108, 109

Raf Simons for Christian Dior
look 21 evening dress
Autumn–Winter 2012 haute couture collection

111

Raf Simons for Christian Dior
toile for look 19 evening dress
Autumn–Winter 2012 haute couture collection

Christian Dior
stocking, ca. 1955

113, 114

Christian Dior
toile for *Bar* afternoon suit
Spring–Summer 1947 haute couture collection,
Corolle line

117, 119

Maria Grazia Chiuri for Christian Dior
toile for *Claude* suit with pleated skirt
Autumn–Winter 2020 haute couture collection

120–121

Maria Grazia Chiuri for Christian Dior
toile for *Numéro 16* long coat
Autumn–Winter 2018 haute couture collection

122, 123

Raf Simons for Christian Dior
toile for look 21 evening dress
Autumn–Winter 2012 haute couture collection

124–125

Raf Simons for Christian Dior
toile for look 54 pleated two-piece dress
Spring–Summer 2015 haute couture collection

127

Christian Dior
Matisse cocktail dress
Autumn–Winter 1949 haute couture collection,
Milieu du siècle line

128–129

Maria Grazia Chiuri for Christian Dior
Baiser rouge quilted dress
Spring–Summer 2017 haute couture collection

130, 131

John Galliano for Christian Dior
toile for look 11 jacket
Spring–Summer 2006 haute couture collection

132

Raf Simons for Christian Dior
look 21 evening dress
Autumn–Winter 2012 haute couture collection

135

Gianfranco Ferré for Christian Dior
Gruau long bustier gown
Autumn–Winter 1989 haute couture collection,
Ascot–Cecil Beaton

138–139

Raf Simons for Christian Dior
look 1 dress
Autumn–Winter 2014 haute couture collection

140, 141

Maria Grazia Chiuri for Christian Dior
Métamorphique dramatic hooded coat
Spring–Summer 2017 haute couture collection

Christian Dior
Romance (detail) bustier dancing dress
Spring–Summer 1956 haute couture collection,
Flèche line

143, 145

Maria Grazia Chiuri for Christian Dior
Polia dramatic dress
Spring–Summer 2017 haute couture collection

146

Maria Grazia Chiuri for Christian Dior
Numéro 355 – L'étoile long draped gown
Spring–Summer 2021 haute couture collection

back cover

Christian Dior
toile for *Braque* semi-evening dress
Autumn–Winter 1949 haute couture collection,
Milieu du siècle line

Quotation references

"Being loaded with the unknown, mysterious, and surprising, fashion has returned to being one of the last repositories of the marvelous."
Christian Dior, translated from "Textes de 1957," *Conférences écrites par Christian Dior pour la Sorbonne, 1955-1957* (Paris: Éditions de l'Institut français de la mode/Éditions du Regard), 20.

"With its lines, its fullness, its shadows, its highlights, the *toile* is in front of me."
Christian Dior, *Talking about Fashion* (London: Hutchinson, 1954).

"A sketch must suggest movement, allure, a gesture; it must be redolent with life."
Christian Dior, *Dior by Dior: The Autobiography of Christian Dior* (London: V&A Publishing, 2024), 86.

"I designed clothes for flower-like women, with rounded shoulders, full feminine busts, and hand-span waists above enormous spreading skirts."
Dior, *Dior by Dior*, 24.

"A dress as I design it is an ephemeral architecture dedicated to celebrating the proportions of the female body."
Dior, *Dior by Dior*, 252.

"Like the sketches that inspired them, the importance of these *toiles* is entirely in their silhouette, cut, and line."
Dior, *Dior by Dior*, 91.

"Whereas the *toiles* leave the imagination free to conceive the rest, dresses are the reality."
Dior, *Dior by Dior*, 101.

Acknowledgments

This project was made possible with the
support of Bernard Arnault, Delphine Arnault,
and Olivier Bialobos.

The House of Dior would like to express its deep
gratitude to Yuriko Takagi.

We would also like to thank the authors
Kazuko Koike and Olivier Saillard for their
important contributions, as well as Paul Neale
and Carole Courtillé at Graphic Thought Facility,
and Catherine Bonifassi and Vanessa Blondel
at Cassi Edition.

Very special thanks to Rikako Yagi for participating
in this project.

We also thank everyone who brought their support
to the realization of this publication:

Christian Dior Couture
Olivier Flaviano, Lucile Desmoulins
Hélène Starkman, Alice Lefèvre, Isabelle Rousset,
Léa Denys, Camille Dupuich
Perrine Scherrer, Solène Auréal-Lamy,
David Da Silva, Joséphine Imbault, Justine Lasgi,
Laura Latapie, Gwenn Meunier, Valérie Mulattieri,
Jessie Rupp, Joana Tosta, Sandra Touraine,
Jennifer Walheim
Daniela Barros, Anne-Charlotte Mercier-Le Tendre,
Thuy Nguyen, Stéphanie Pélian

Christian Dior Parfums
Frédéric Bourdelier, Vincent Leret, Inès Allain Balbine

Christian Dior G.K.
Emma Yamaguchi, Emi Mizuguchi

As well as Amanda Ling-Ning Lo.

Yuriko Takagi would especially like to thank
Olivier Bialobos for making this book possible,
for his deep understanding and trust in her proposal,
which gave her the complete freedom to shoot.
She also wishes to thank the Christian Dior Couture
team for their generous and heartwarming assistance
in this project.

Credits

Photography
Yuriko Takagi

Assisted by
Shinnosuke Miyachi
Cameron Koskas

Models
Lia Kemendi (Oneness Entertainment):
pp. 27, 31, 73, 76, 77, 90, 91
Sia Prykhodko (Premium Models):
pp. 35, 48, 74–75, 86, 89, 95, 120–121
Anna Van Dieren (Ulla Models):
pp. 15, 16–17, 19, 20, 22–23, 28–29, 32, 36–37,
38–39, 42–43, 46–47, 49, 53, 60–61, 62, 63,
64–65, 66–67, 68, 79, 92, 93, 96, 99, 102, 104–105,
108–109, 111, 113, 114, 117, 119, 122, 123, 127,
128–129, 132, 135, 138–139, 140, 141, 146, back cover
Rikako Yagi (Asia Cross):
pp. 54–55, 56–57, 143, 145

Makeup
Delphine Delain
Estelle Jaillet

Hair Styling
Lauren Berrones

Manicure
Gwénaëlle Navarro (Majeure prod)

Management and Mannequin Styling
Hannah Morelle
Marine Seira

Set Design
Les Décors Papillons
Alexander Bock, Flavien Perrottey

Video Projection
La Méduse
Éric Duranteau, Cléo Sens, Edoardo Cecchin

Espace Lumière Studio
Julien Verdure

DIOR by Yuriko Takagi

First published in the United States of America
in 2025 by
Rizzoli International Publications, Inc.
49 West 27th Street
New York, NY 10001

Copyright © 2025 Christian Dior

Photography: Yuriko Takagi

Foreword: Kazuko Koike
Text "*Toiles*, Outlines of the Dress": Olivier Saillard

All rights reserved. No part of this publication
may be reproduced, stored in a retrieval system,
or transmitted in any form or by any means,
electronic, mechanical, photocopying, recording,
or otherwise, without prior consent of the publisher.

Publisher: Charles Miers
Editorial Director: Catherine Bonifassi
Production Manager: Maria Pia Gramaglia
Managing Editor: Lynn Scrabis
Copyeditor and Proofreader: Tricia Levi

Design: Graphic Thought Facility

Editorial Coordination and Production: Cassi Edition
Vanessa Blondel, Candice Guillaume,
Cyriane Flamant, Abigail Grater, mot.tiff inside

Image processing and printing: Printmodel Paris

Typeset in Recital (Malte Bentzen, 2023)
and Tenko (Julian Morey, 2025)

ISBN: 978-0-8478-7424-8
Library of Congress Control Number: 2025933410
Printed in Germany, bound in Italy
2025 2026 2027 2028 / 10 9 8 7 6 5 4 3 2 1

The authorized representative in the EU for product
safety and compliance is
Mondadori Libri S.p.A., via Gian Battista Vico 42
Milan, Italy, 20123
www.mondadori.it

Visit us online:
Instagram.com/RizzoliBooks
Facebook.com/RizzoliNewYork
X: @Rizzoli_Books
Youtube.com/user/RizzoliNY